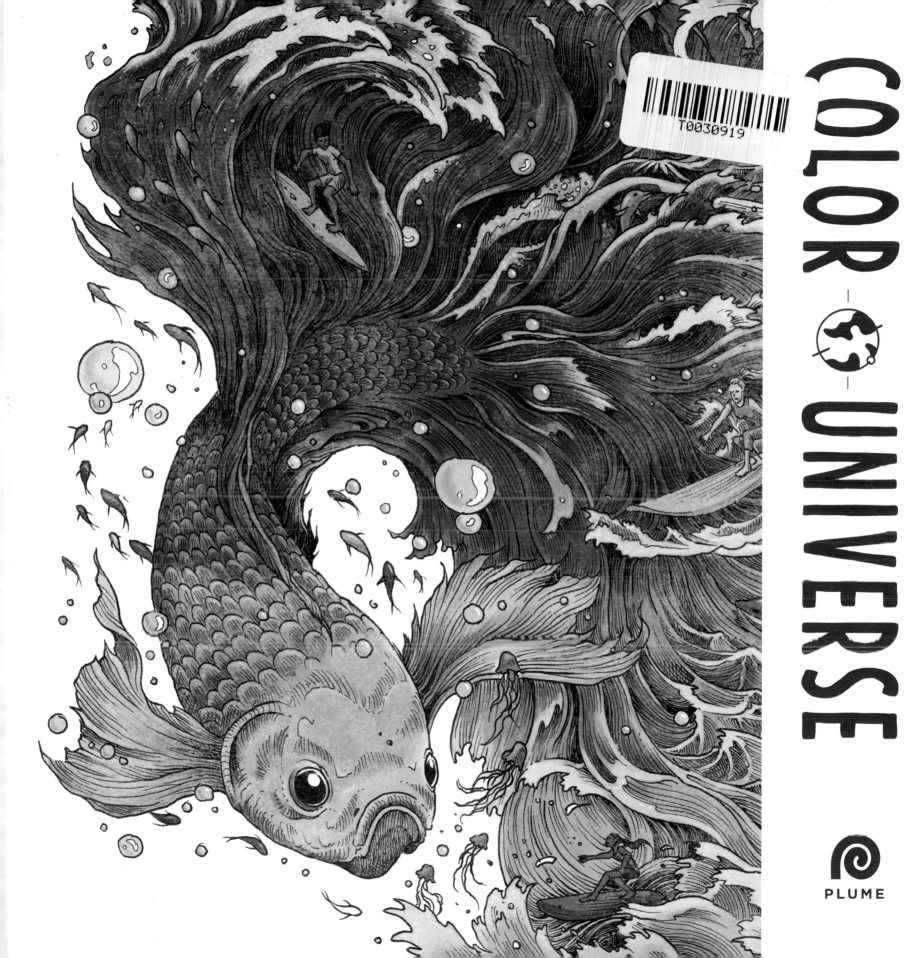

COLOR
— UNIVERSE

PLUME

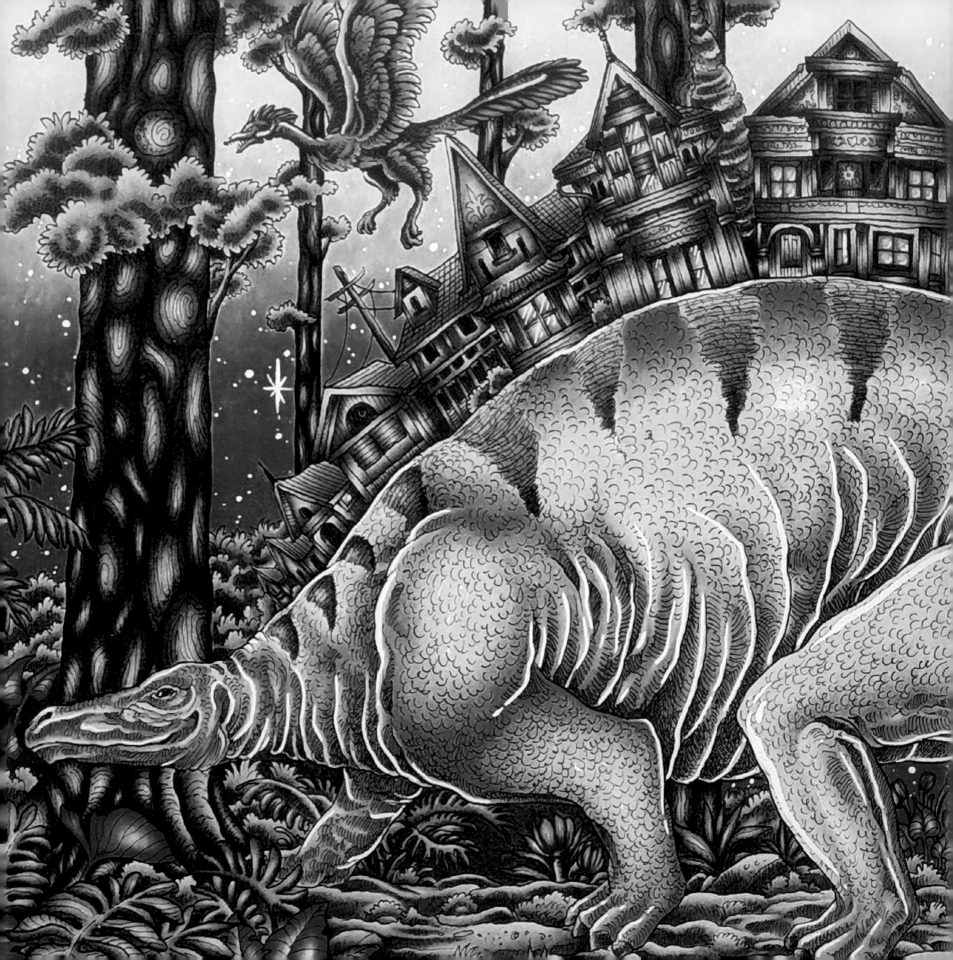

Dive into a universe of color . . .

Explore curious alien life-forms and majestic mythological realms, as well as beautiful creatures from our own natural world.

In this book, you'll find a selection of images that I have personally chosen from across my *World* series. They're ready for you to bring to life with a whole universe of color.

To inspire your creativity, I have included a selection of images completed by some exceptionally talented colorists. Discover their choices of color palette, skilled blending and shading techniques, and their unique, creative additions and innovations. I have described what, in my opinion, makes each piece so special, and have suggested coloring tips and tricks that you can use in your own work.

It's time to be inspired to create your own coloring masterpieces.

Kerby Rosanes

Staggering Stegosaurus—Two Worlds Collide in Color (previous page)
Colored by Laëtitia Thouard, a.k.a. @ceubei_colos

Moss greens and cedar browns coexist with raspberry pinks and cobalt blue to represent the meeting of contrasting worlds in this piece.

A bold sky moves seamlessly from fuchsia through neon orange to meet a pastel yellow. This provides a striking backdrop to match the impact of the imposing *Stegosaurus* in the foreground, as it moves powerfully through its forest habitat.

The colorist has paid close attention to every detail of the artwork, bringing the elements together to create one coherent universe. The ground beneath the dinosaur's feet has been shaded intricately to bring the natural, rocky terrain to life. The rooftops reflect the sunset colors of the sky, and the cobalt blues on the smaller dinosaurs, flora, and windows provide refreshing pops of color around the scene.

Natural hues on the earth, the row of houses, the tree trunks, and foliage help to both neutralize and highlight the intense bursts of color used for the dinosaurs and the sky.

A white gel pen has been used to highlight the folds in the dinosaur's skin, its scaly companions, and the windows of the houses. This not only accentuates reflected light but also gives further depth to the scene. The colorist has used the same pen to add their own artistic vision in the form of stars and twinkles in the sky. This adds to the luminous quality that they have achieved through their choice of glowing colors.

This is a beautiful example of how bold colors can ignite wonder while simultaneously creating an exquisite sense of calm.

Moonlit White Stag—Experimenting with Light and Shadow (facing page)
Colored by Laila Heldal, a.k.a. @colourwithlh

Nighttime scenes can be among the most challenging to color, but also the most rewarding. In a deep, dark forest, lit only by the full moon, color is at its most limited, but also at its most visually effective.

The colorist's understanding of light and shade is crucial to making this piece work. Notice how they have placed a lemon-yellow glow only on the scene's key edges: the sides of the trees, the tops of leaves, and the outlines of the stag's powerful body. The highlighting on the antlers intensifies toward the center, where they become fully illuminated to the point that they almost seem to merge into the lunar glow behind.

Despite the scene's inherent darkness, black is used surprisingly sparingly. The only instances of pure black are found in the birds rising up into the night sky and within the deepest crevices of the foliage. The birds are the only elements of the scene shown fully in silhouette, offering a stark contrast to the detailed shading that is achieved elsewhere in the image.

Notice the figure of the hunter on the left-hand side, deliberately left in darkness and almost imperceptible against the gray-blue trunk of the tree. When it comes to coloring a scene of this nature, sometimes less is undoubtedly more.

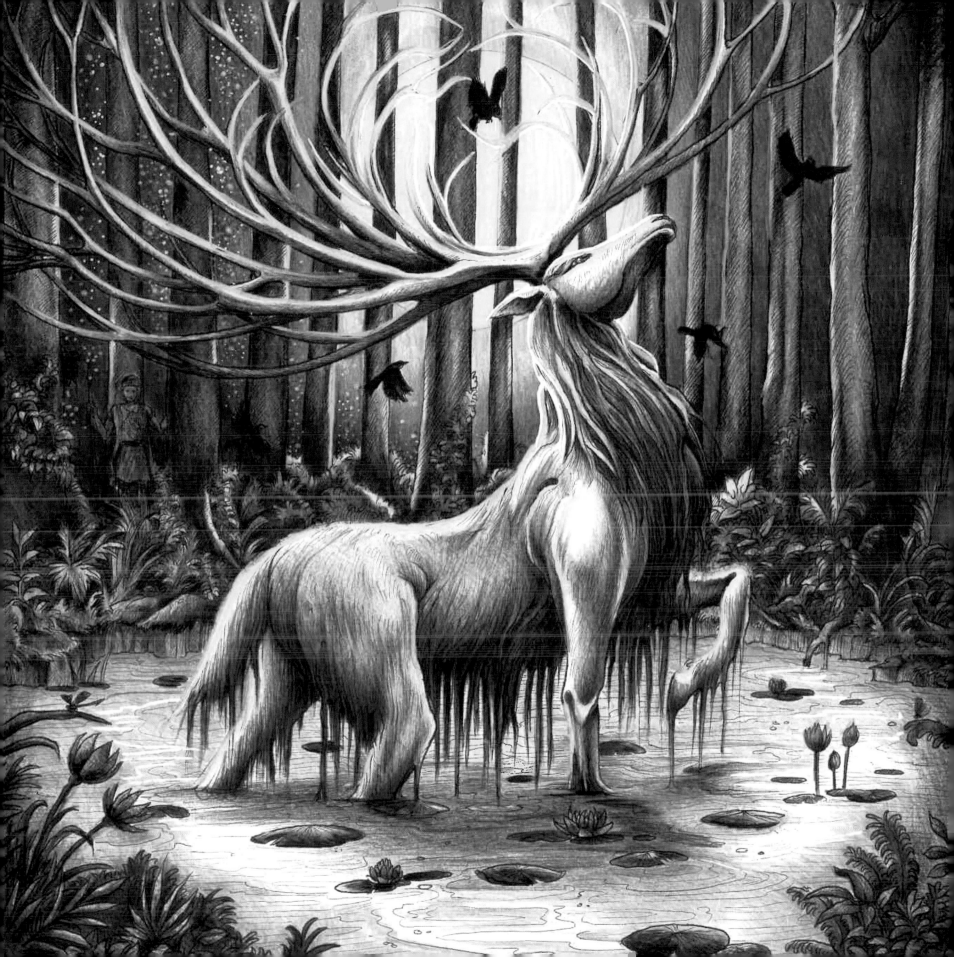

Through the Eyes of Nature—An Interpretation of Bold Resilience (facing page)
Colored by Claudine Charteau, a.k.a. @mes_passions_colorées

The natural world is presented at its brightest and boldest in this compelling image of a mandrill—one of the most colorful mammals on the planet.

The colorist has worked with the existing composition to present layers of color. First, there's the multicolored vegetation that frames the piece, then the glossy browns and yellows of the mandrill's fur, and lastly the central explosion of fuchsia pink and azure blue.

The zingy yellow of the bananas, the ripe berries in reds and purples, the punchy oranges and pinks of the flowers, and the vibrant green leaves all contrast with a stark, black background. Simple yet powerfully effective, this plain, impenetrable black does more than just make the colors pop. The inky background also enhances the drama of the scene—a fitting backdrop for such a striking creature.

That sense of contrast is boosted further still by the colorist's decision to use light tawny browns, rust oranges, and saffron yellows for the creature's mane. While darker shades may have left the mandrill lost in the undergrowth, these lighter hues bring the animal bounding into the foreground, where its bold snout is front and center.

Legendary Loch Ness—Scaling Up Attention to Detail (next page)
Colored by Laëtitia Thouard, a.k.a. @ceubei_colos

This piece provides a gorgeous example of how color can be used to subvert expectations. Normally, we'd expect both the sea and the sky to be shades of blue. However, this colorist has opted for waves of deep pink and a sky that fades from the very darkest violet to a stunning, contrasting shade of golden yellow.

Before starting work, the colorist made a conscious decision to limit their color palette to pinks, purples, and yellows, with a central band of steel blue. While it might be tempting to throw as many colors at a composition as possible, the finished work here demonstrates just how effective it can be to choose a smaller range of colors and stick with them.

Within each band of color, the colorist has used three to five different shades of pencil, before accentuating with a blender pencil for added shine and pigmentation. This almost gives the piece a glossy finish, enhanced further still by the careful placement of white highlights. A closer look at the sea monster reveals these details, as shown on the highlighted scales along the ridges of the monster's arched back, helping it to stand out against the sea and the sky. The colorist achieved this by using a white gel pen. A golden acrylic gel pen was also used on the towers in the foreground to create glinting metallic areas.

These clever techniques, employed to add a three-dimensional sheen, enhance the otherworldliness of the original art.

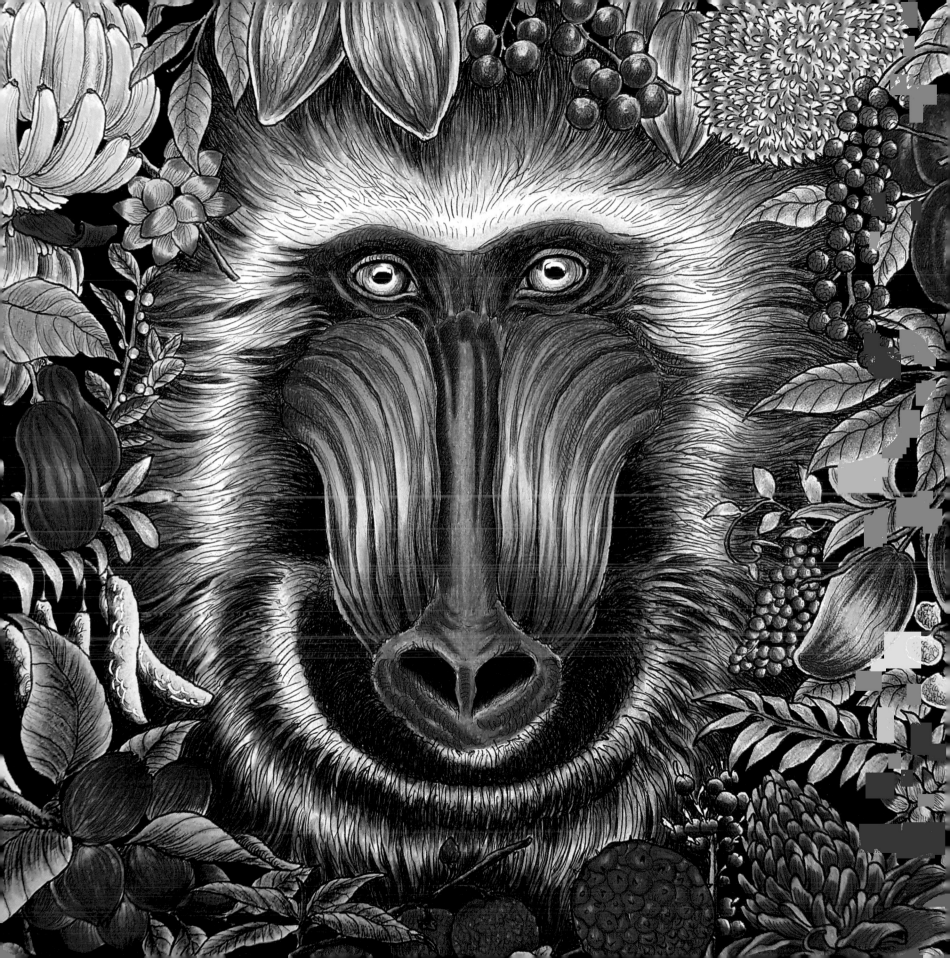

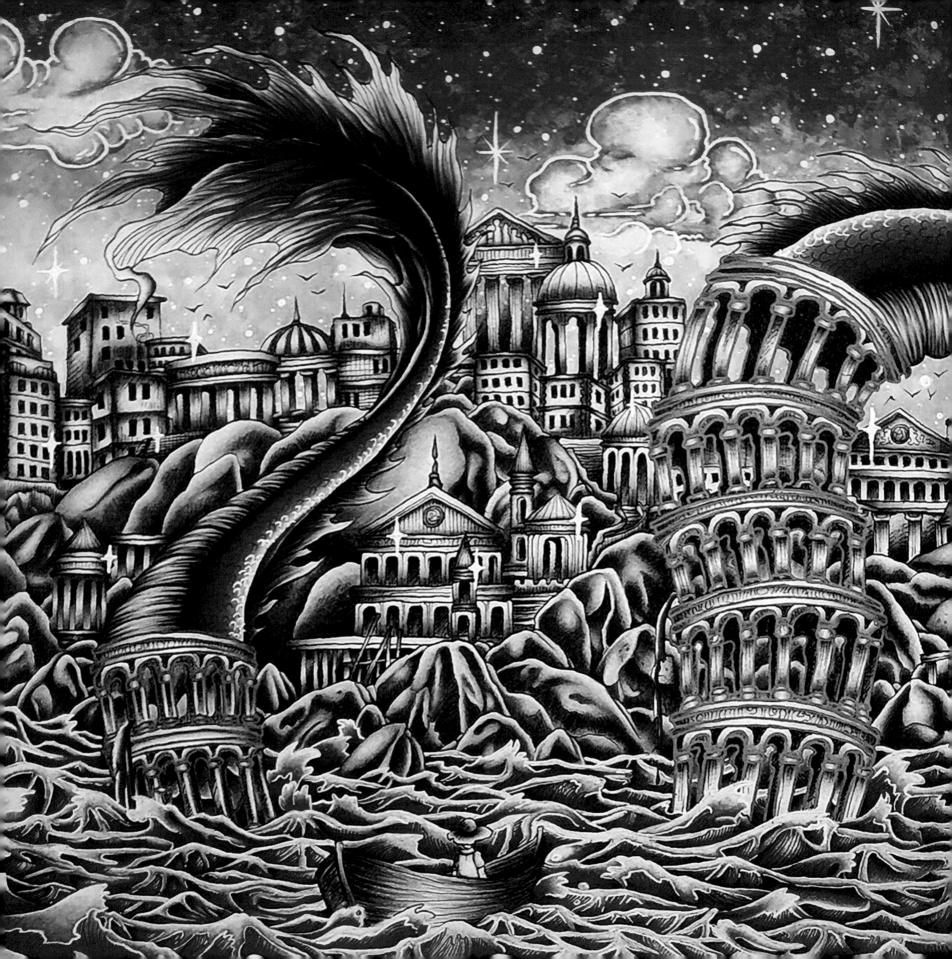

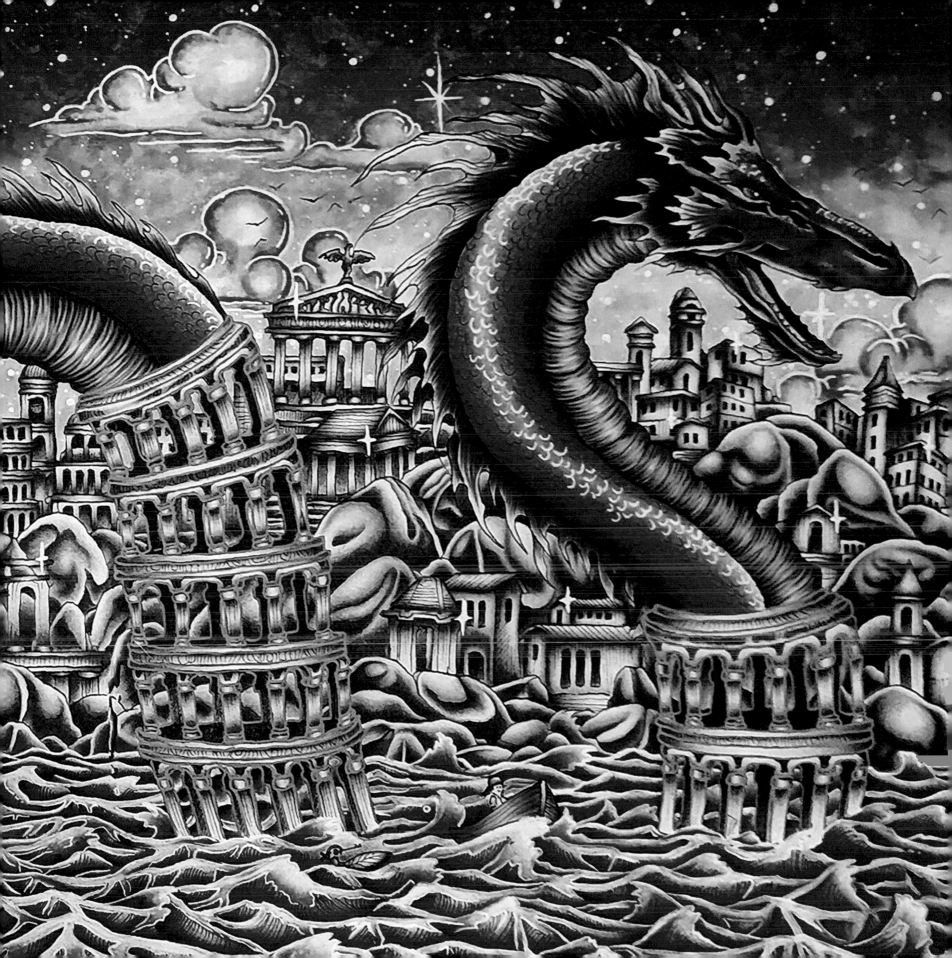

Extraterrestrial Encounter—Creating a Celestial Glow (facing page)
Colored by John Bigwood

Using digital techniques, this colorist has masterfully captured the ethereal quality that I had in mind when I created this alien world.

A complementary palette of lime green and deep purple has been selected. The purples and blues framing the left-hand side of the scene are mirrored and used on the right side of the towering, tentacled predator. This helps to highlight the creature—an apt interpretation of its dominance in this alien world. The astronaut, shaded in lighter, lilac tones, stands out as its object of prey.

The purples and blues of the creature have been mirrored and combined in subtler hues on the rocky temple ruins, to imply that this civilization created in the past is now commanded by alien life-forms.

A vignette framing effect is achieved through soft shades of indigo, blending gradually darker into the four corners of the scene. Small areas of the piece have been left white or shaded in neon-lime tones to highlight elements or to achieve a reflective glow. These green tones and glowing white areas give this world an eerie, supernatural feel.

The colorist has added their own innovative elements. If you look closely at the alien creature, you can see that it radiates a soft yellow-green glow, combined with small floating orbs of light that help to highlight this curious creature and create the illusion of levitation. A celestial spiral in the sky provides a fitting mystical backdrop to the drama.

This is a prime example of how a colorist's own artistic inventions can yield stunning results.

Prismatic Protectors—Creating a Sense of Harmony (next page)
Colored by Laila Heldal, a.k.a. @colourwithlh

This piece presents a whirlwind of magnificent creatures, each taking up one of the main points of the compass in Chinese mythology. The colorist here has cleverly matched that circular configuration to the positions of the color wheel, and created a spiral of merging shades, progressing from north to east, to west and back to north again.

No matter what point you start at on the color wheel, the adjacent sections show a closely related shade, and that's exactly how the color choices work here. See how the orchid color of the turtle's shell progresses to the deep violet of the dragon's flank. This violet moves to a ruby pink as we cross the body of the phoenix, from wing tip to beak.

It morphs again from crimson red to fiery orange as we reach the tiger.

A similar progression can be seen in the turquoise of the turtle's body, which moves to striking blue on the dragon's spine and underbelly. Pops of cerulean sky-blue appear amid the bird's feathers, and finally a dark navy on the rocks that support the weight of the tiger.

The background maintains its neutrality with a salmon shade of pink, closely complementary to all four creatures but not dominant within any of them.

Colors can contrast or they can harmonize, and in this example we see just how powerful and effective it can be to opt for the latter over the former.

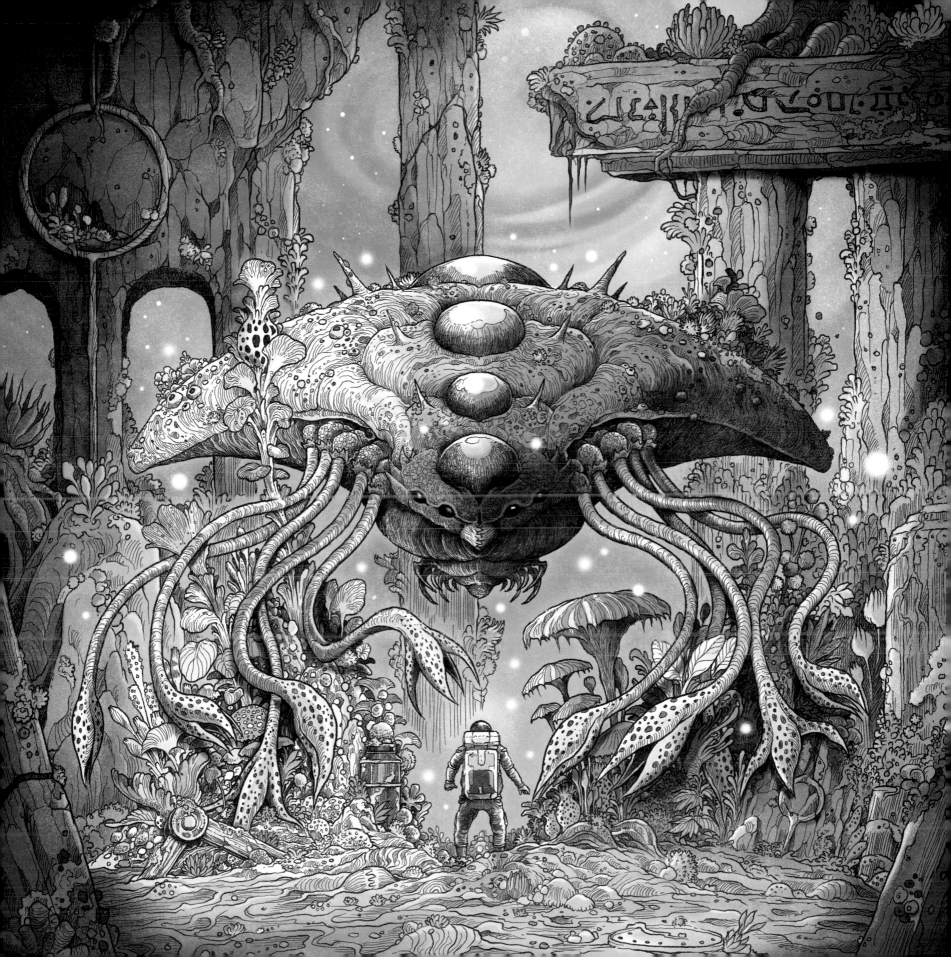

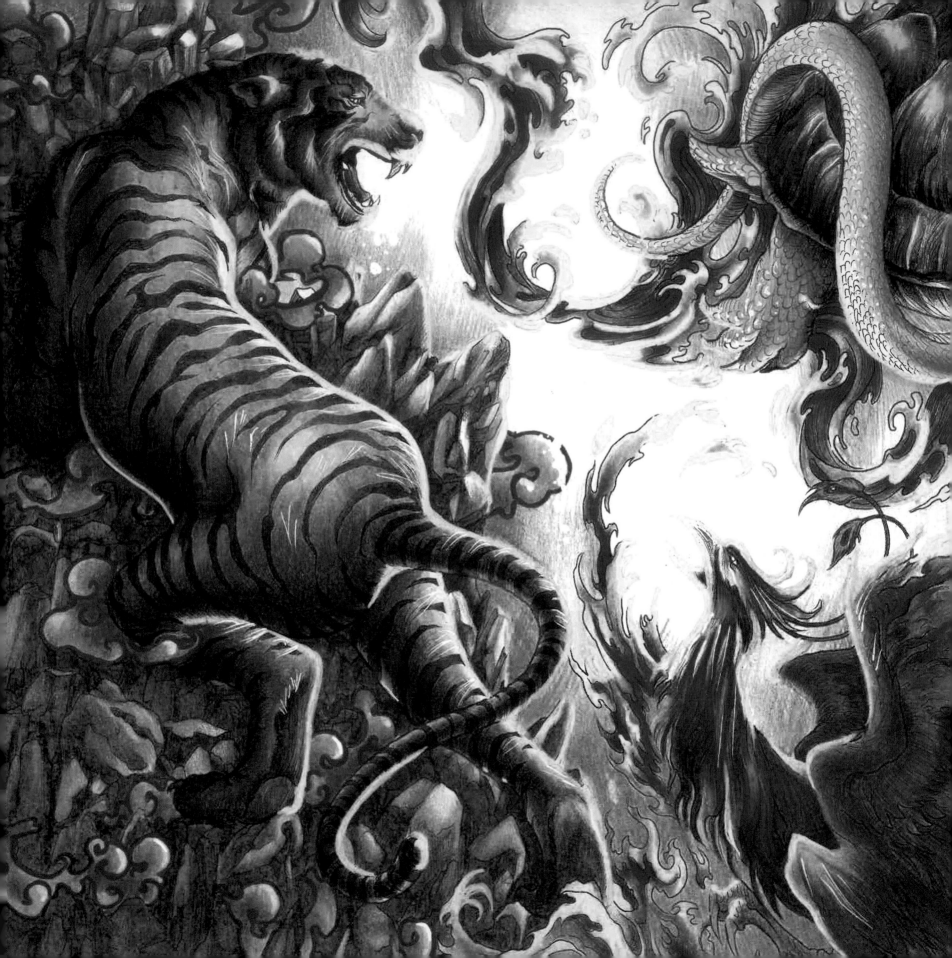

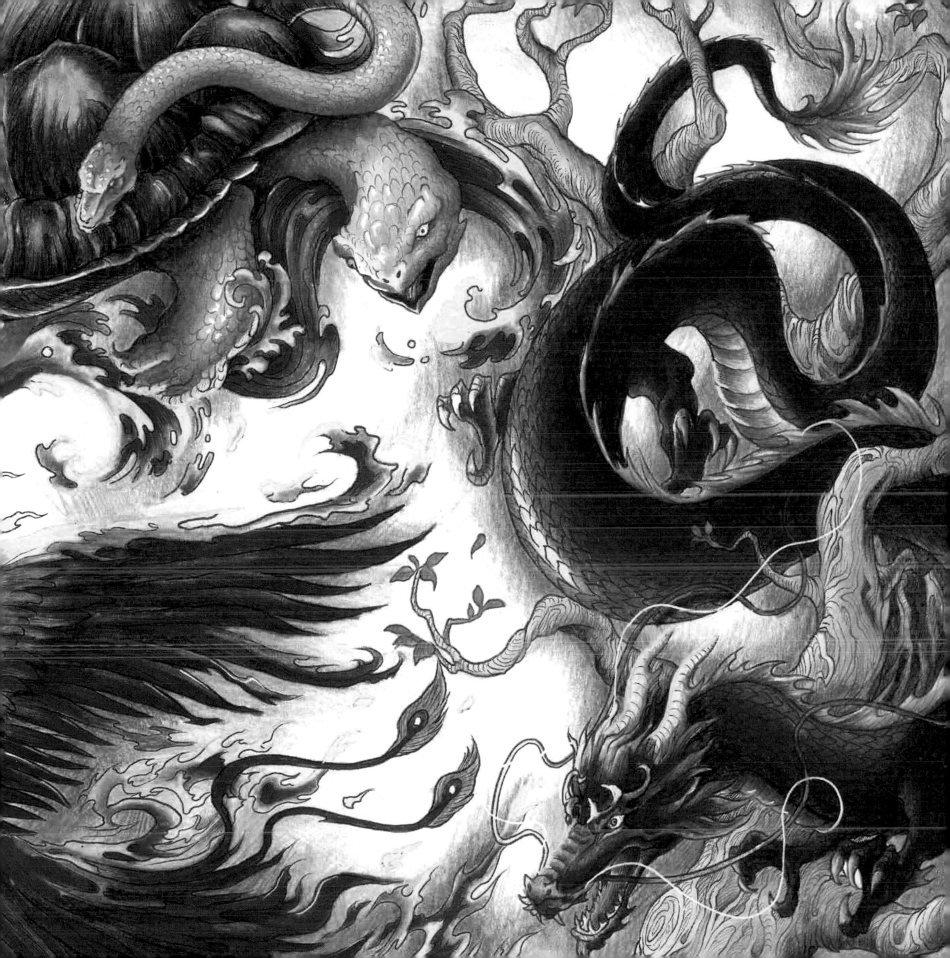

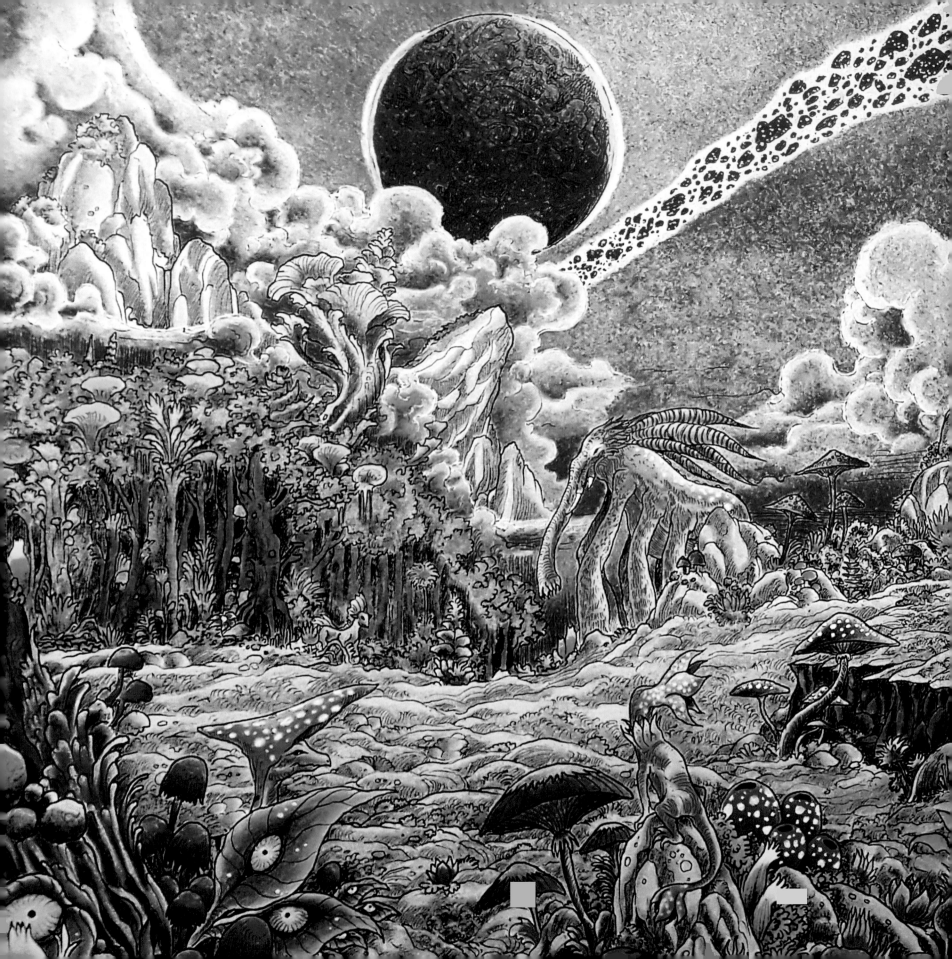

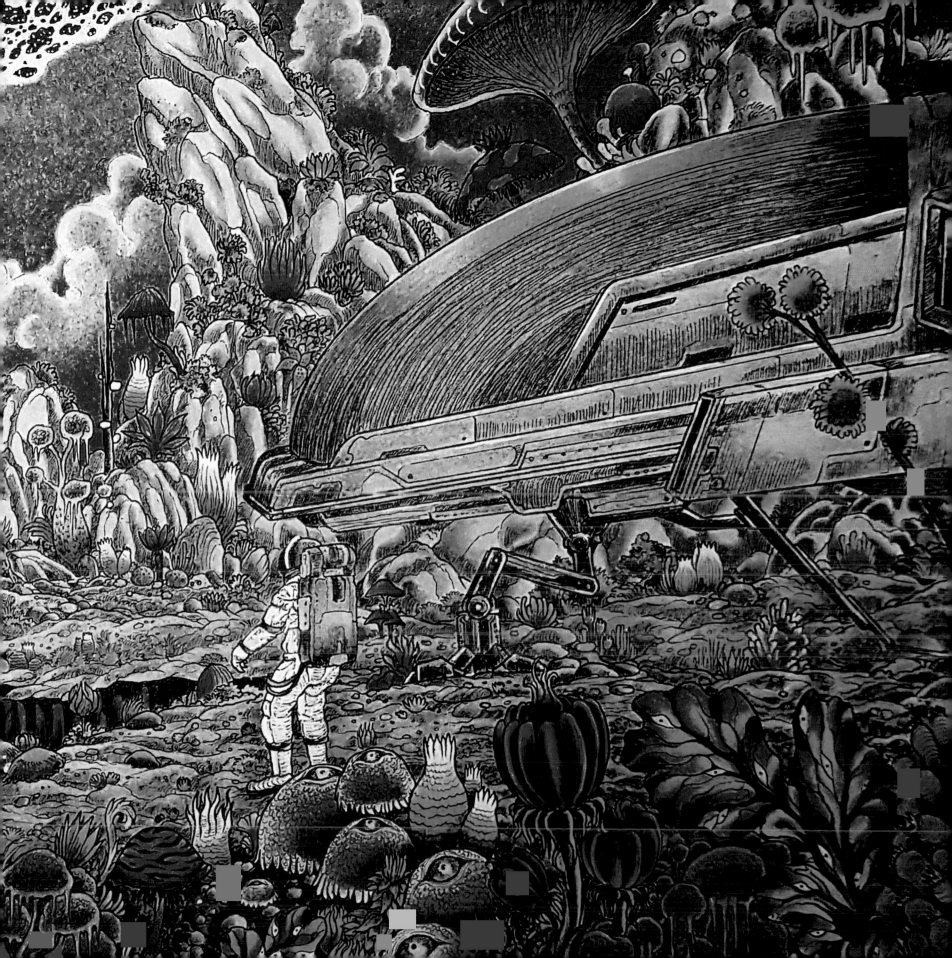

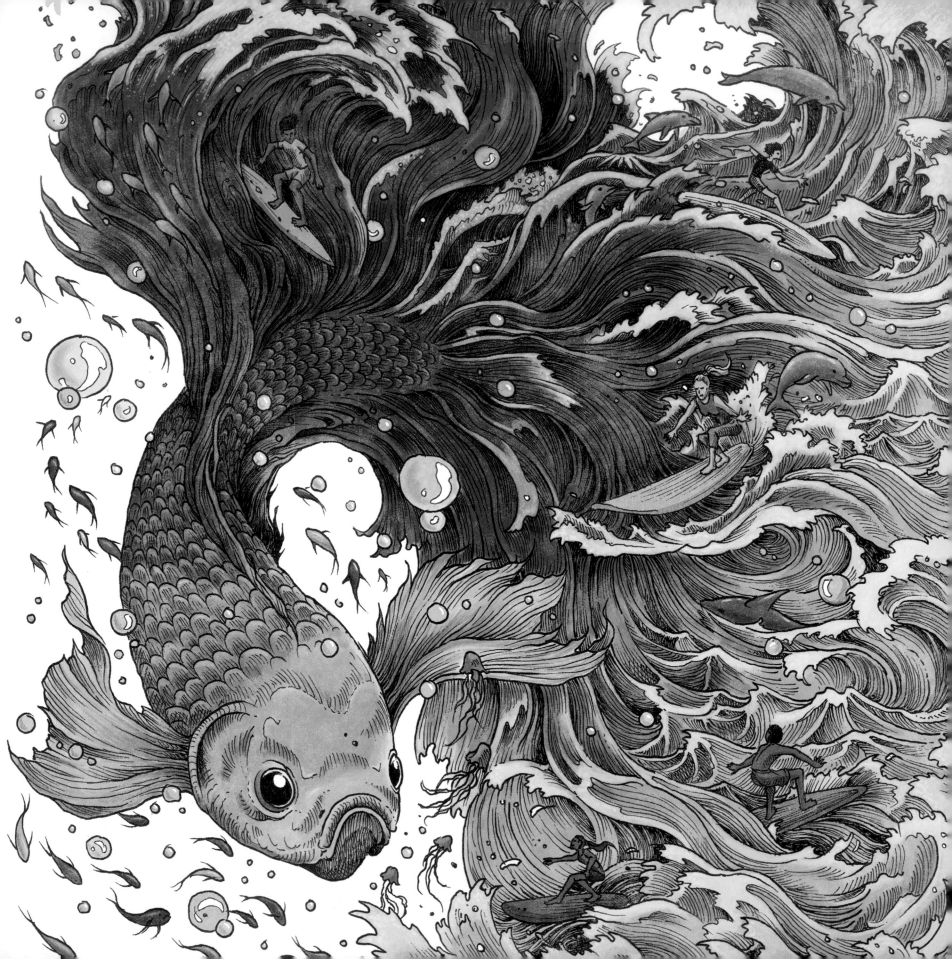

Out of this World Tranquillity—A Bold Yet Balanced Approach (previous page)
Colored by Claudine Charteau, a.k.a. @mes_passions_colorées and Derrian Bradder

This lush landscape has been brought to its full, vibrant potential through close attention to detail and carefully considered techniques. This piece was first colored with traditional materials and then touched up with digital techniques to enhance the colors and shading.

The colorists have used sharp and strong contrasting colors for the peculiar plant life that thrives here, opting for rich shades of raspberry pinks, amethyst, and cerulean blue. Notice the attentive blending of two or three colors on each plant, which gives the impression that they are humming with life.

In contrast to the electric colors in the foreground, the colorists have chosen a more subdued, textured approach for the background sky.

A stippling technique, combined with the rolling, softly colored clouds that blur the black illustration lines, creates a harmonious balance with the dense, tropical life buzzing below. This harmony prevents the landscape from overwhelming the eye—while the use of color is bold, it has been thoughtfully balanced throughout.

The middle section has been treated with a simpler wash of yellow-green, punctuated by creatures in a glowing tangerine color and colored earth and tree trunks. Natural shades here help to break up and accentuate the more dominating elements of the artwork.

The outcome is a sublime and immersive paradise, teeming busily, yet serenely, with life.

Breaking Waves with Color—Transition to Enhance Movement (facing page)
Colored by Lauren Farnsworth

A sweeping, dynamic image such as this might seem daunting to tackle, but this colored piece showcases the way that careful planning and blending can be used to enhance movement.

The fluidity of the subject matter of this piece is expertly mirrored in the colorist's fluidity of transitional color. From the bottom left, swooping up and over to the right, they have progressed around the whole color wheel, as well as creating a masterful migration from warm to cool tones. The result is a variegated riot of color, which brings the image to life with stunning effect.

The body of the fish begins with honey yellow that blends harmoniously with fiery orange. Moving toward the tail, the orange merges with a bright fuchsia pink and then to a deep ombré mauve. By this point, the tail is exploding into waves, which the colorist treats with washes of pastel blue blending to a light teal. The waves are tipped with an icy, arctic blue, highlighting the crests and breaks in the waves.

From these six focal colors, the colorist has matched shades to each of the surfers' boards and swimsuits, as well as for the breaching dolphins and other sea creatures, to emphasize the coordination and coming together of two worlds.

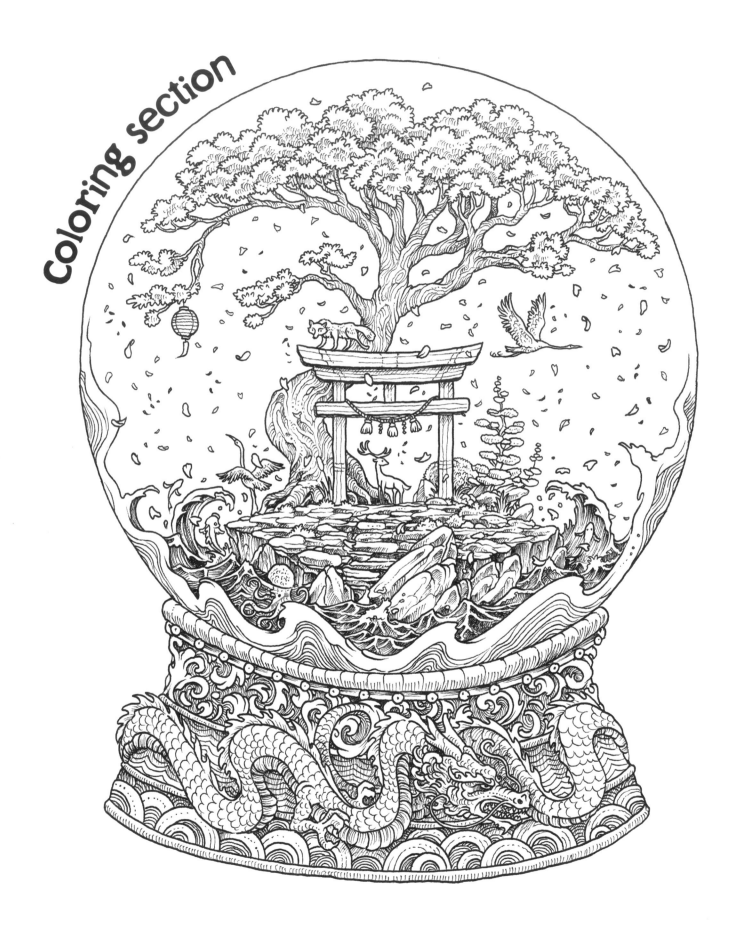

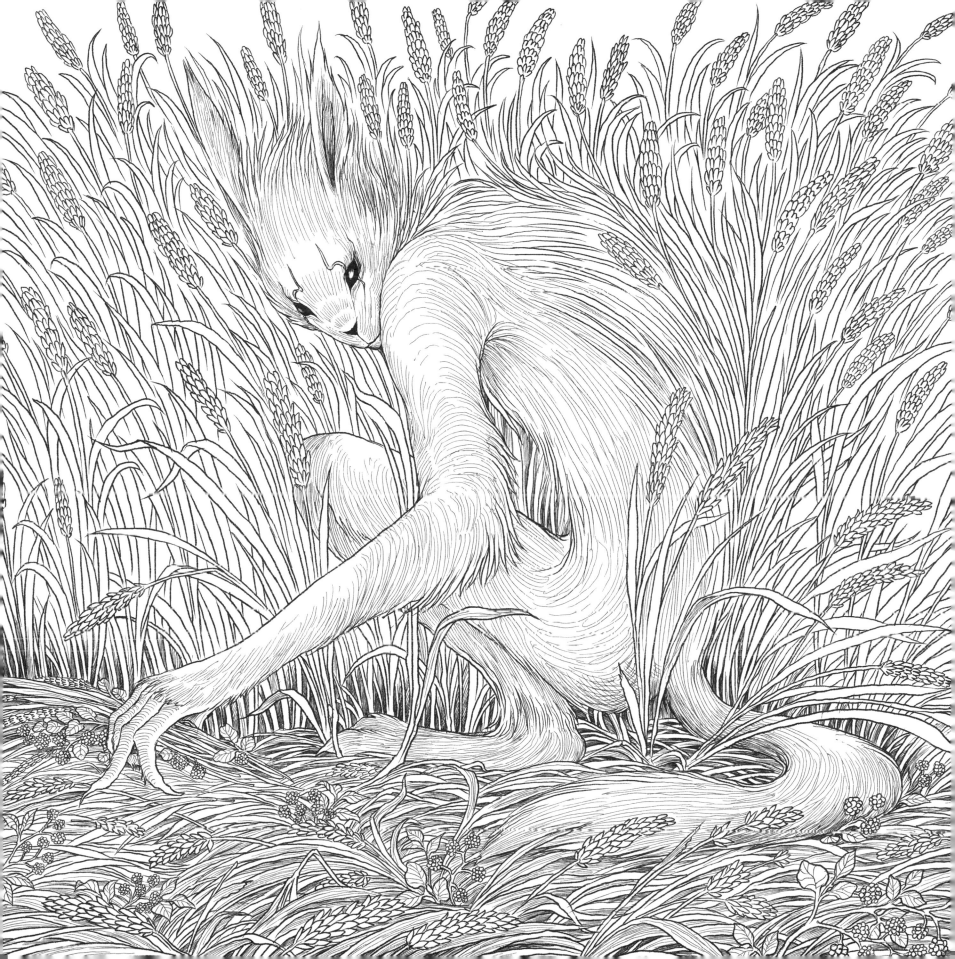

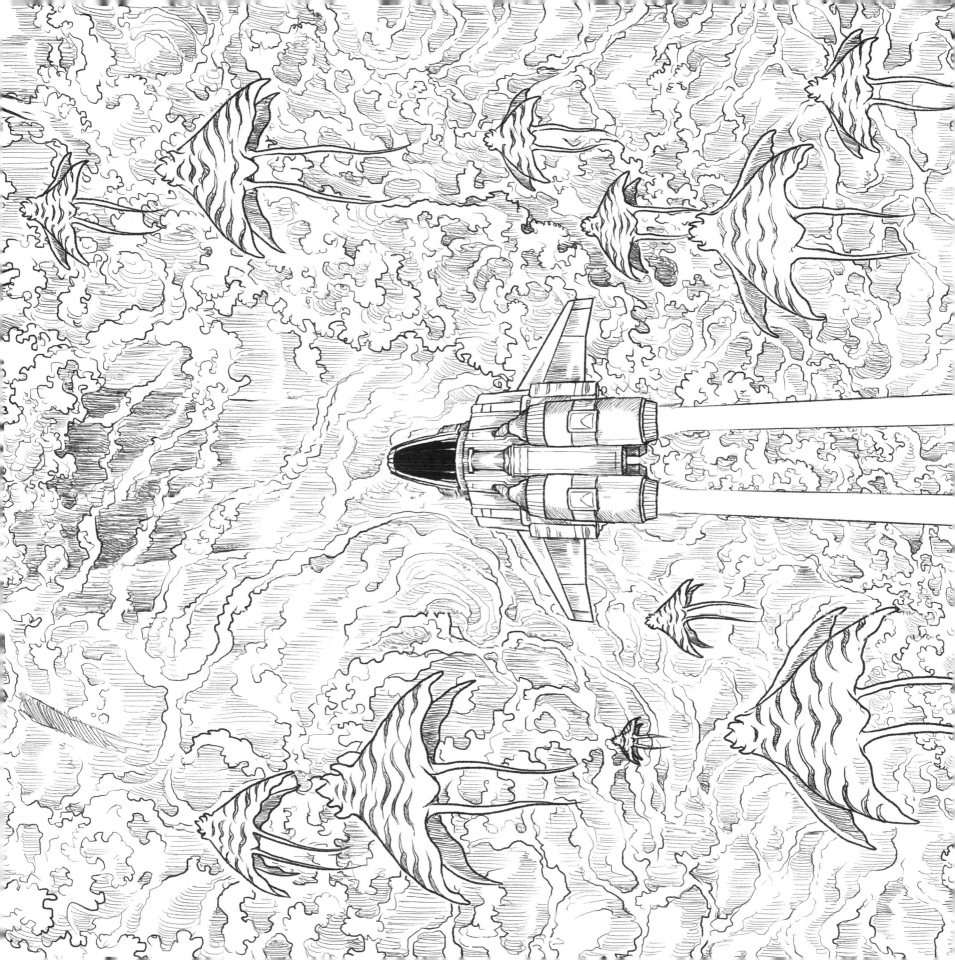

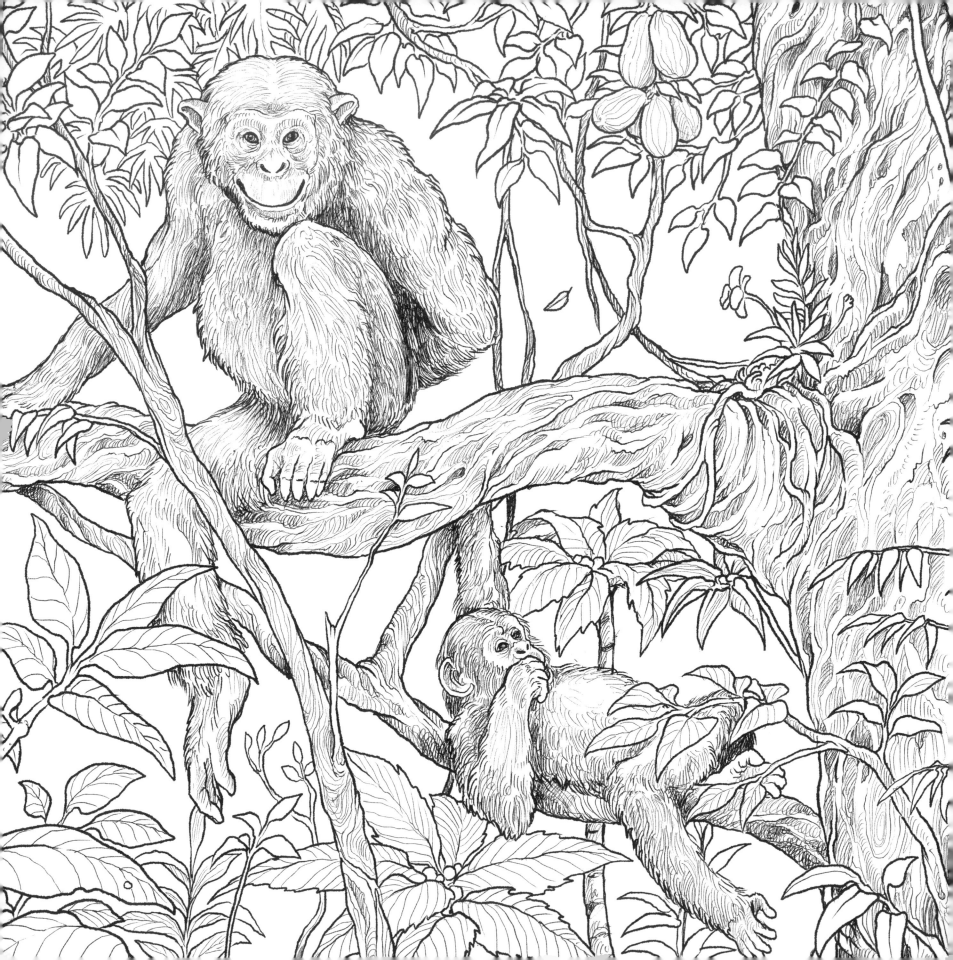

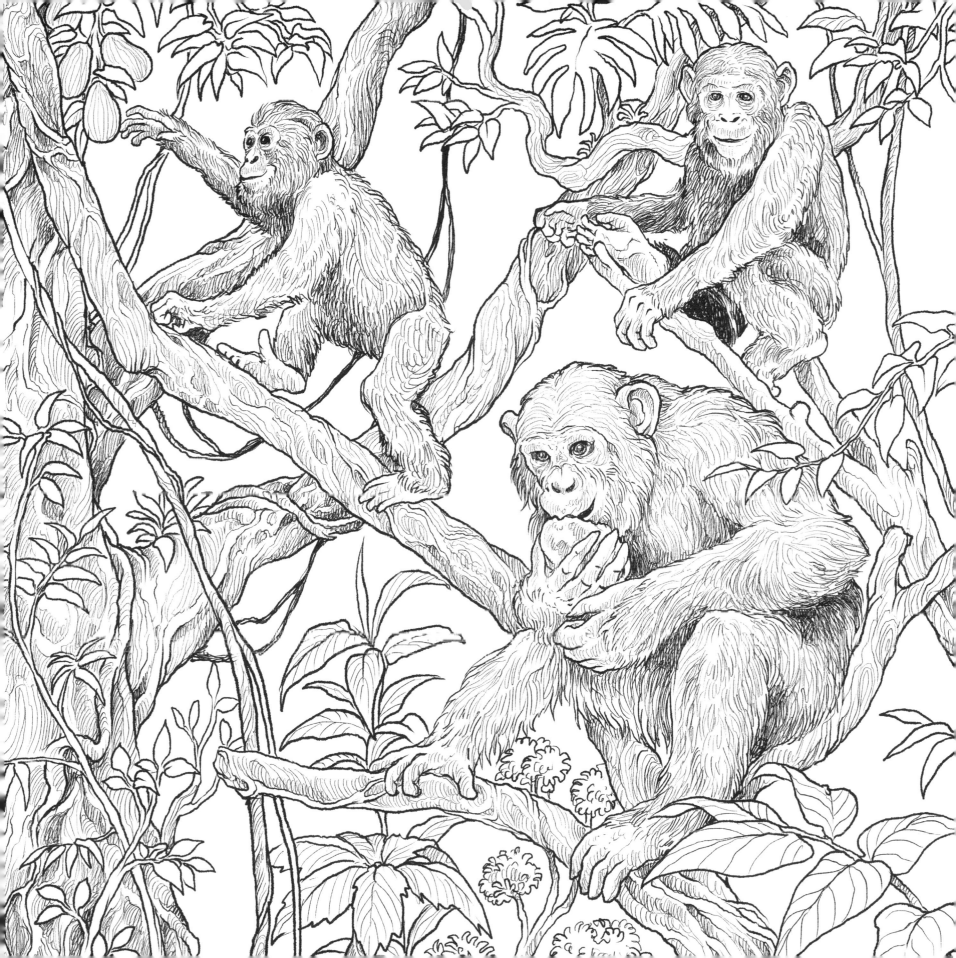

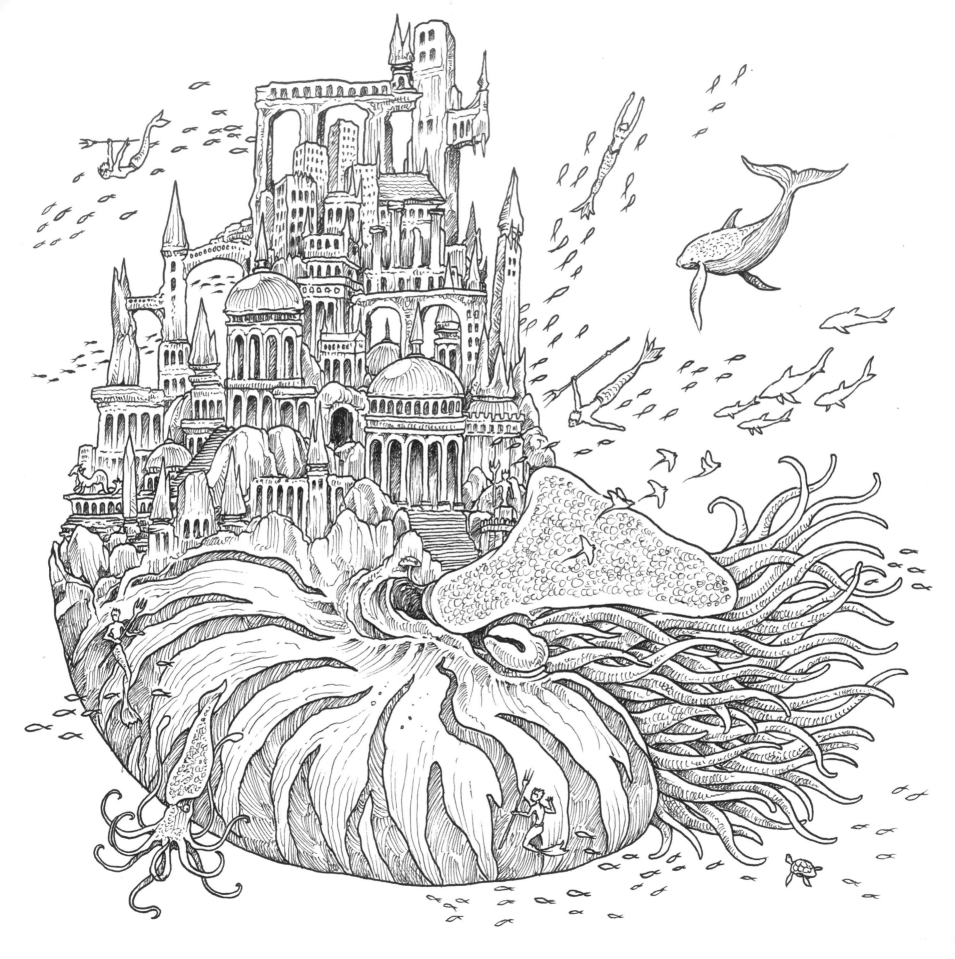

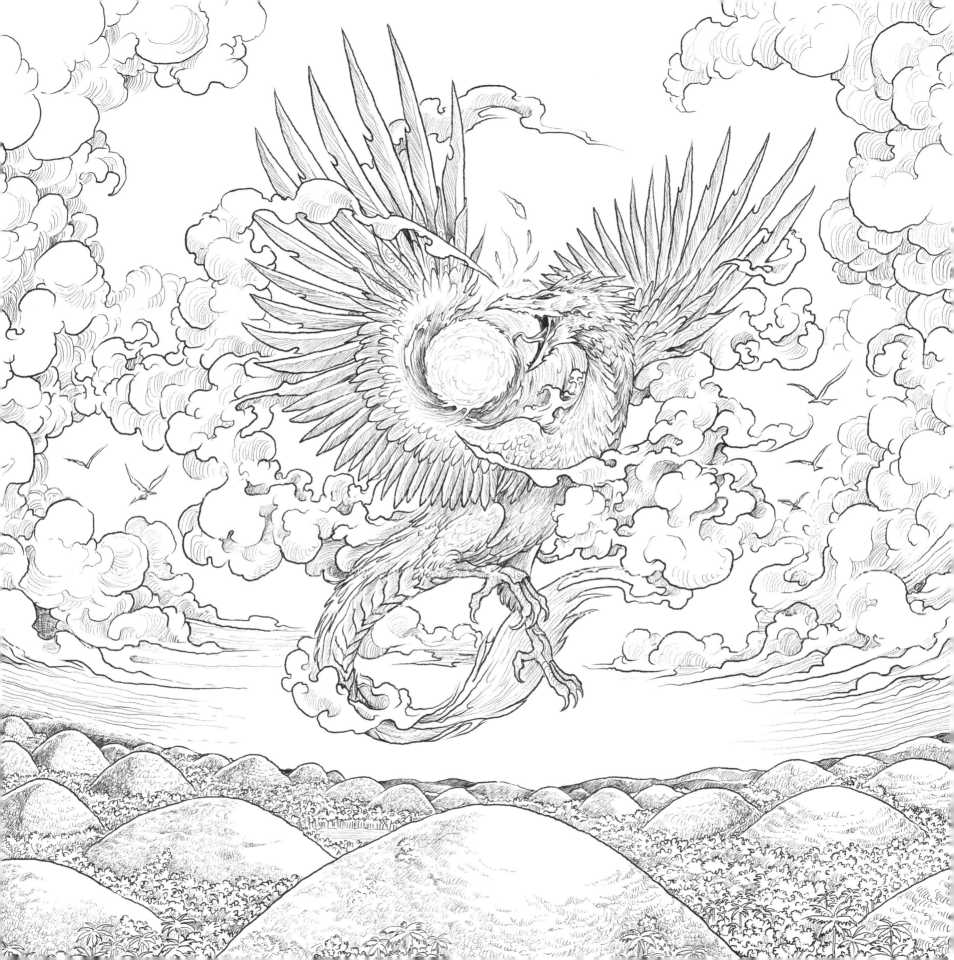

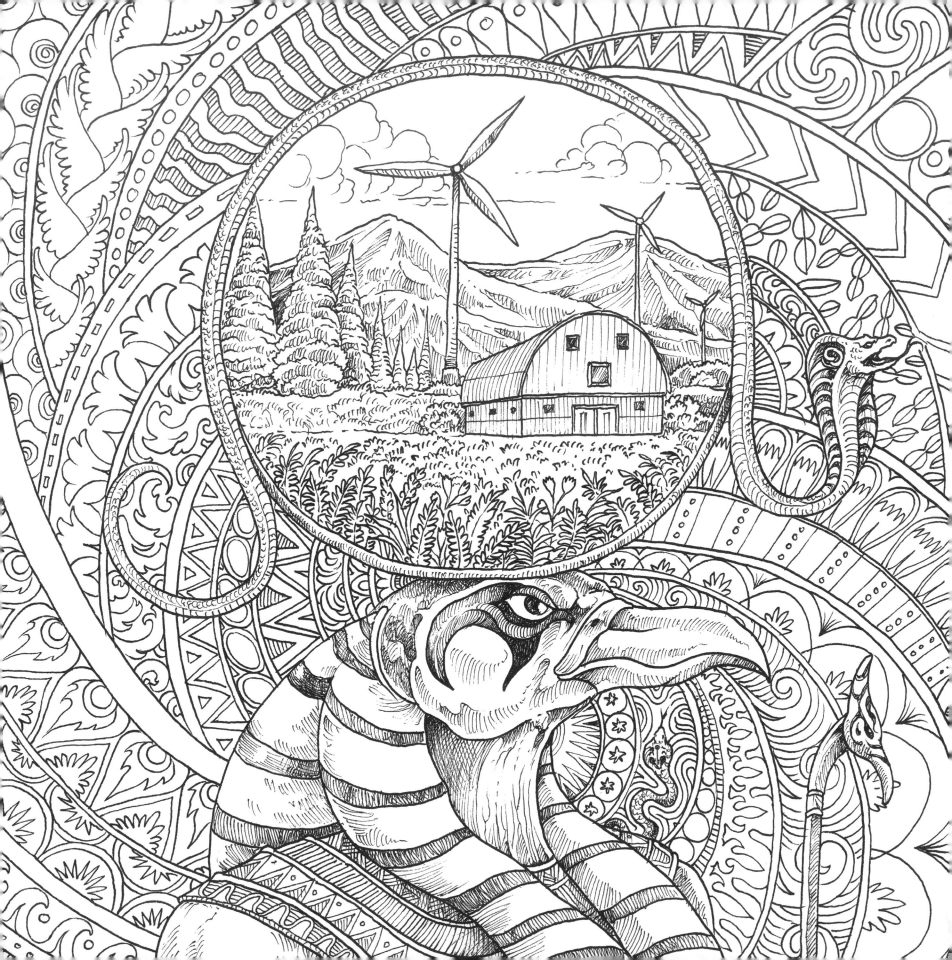

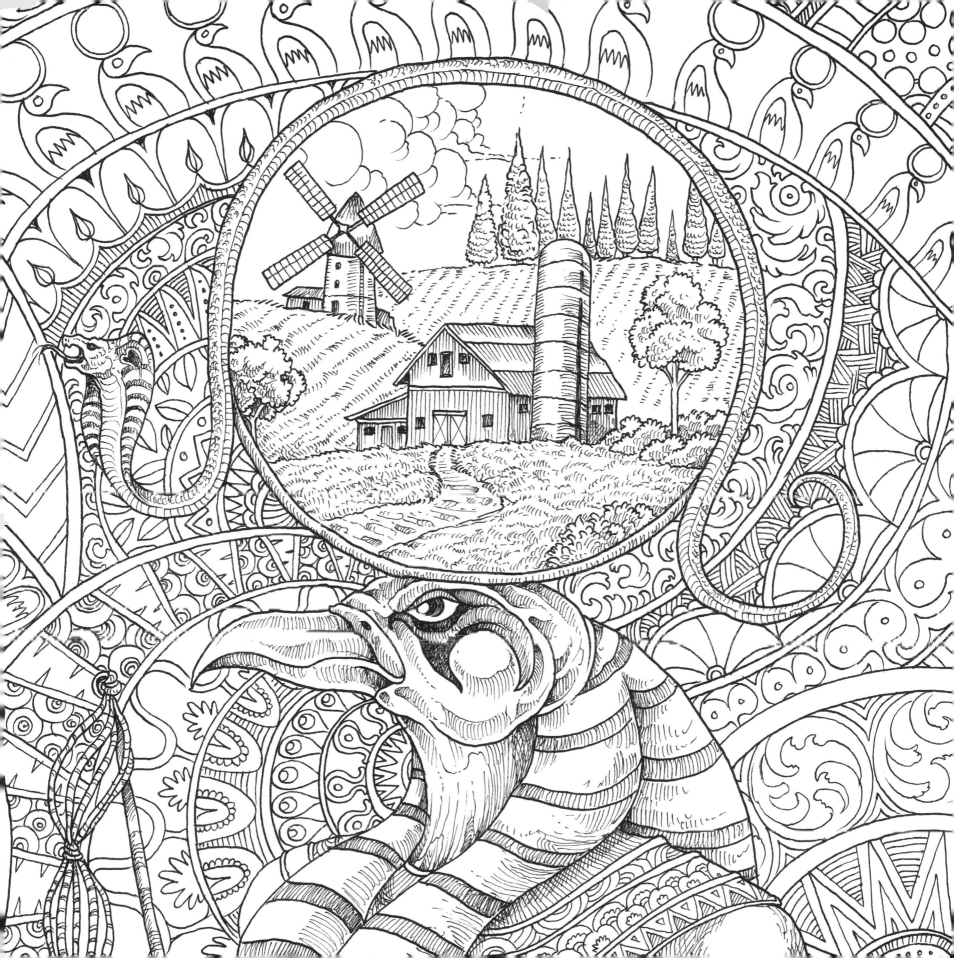

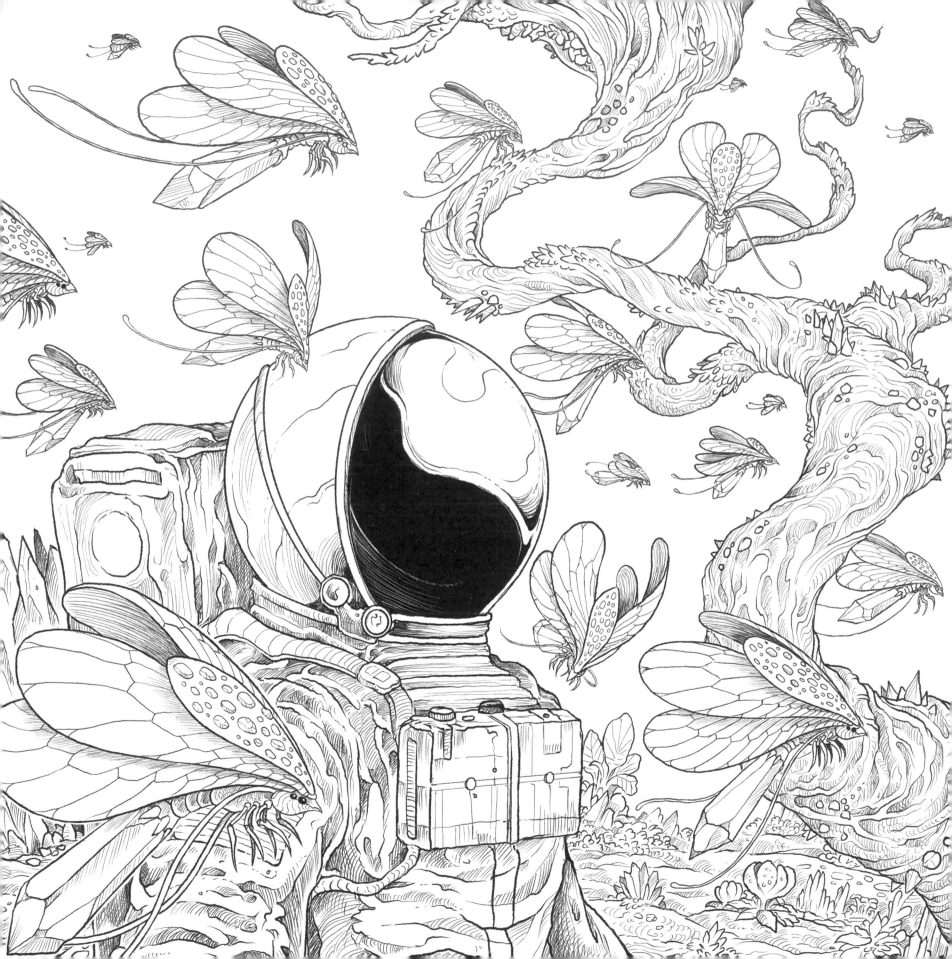

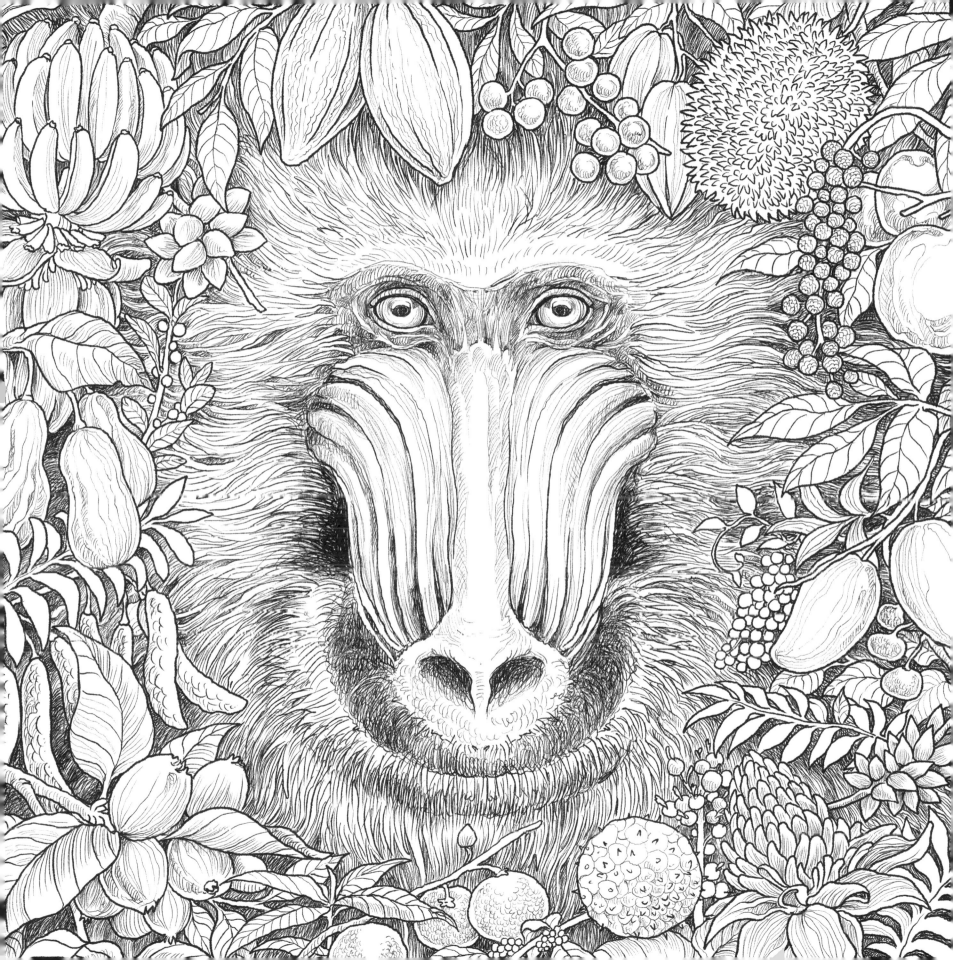

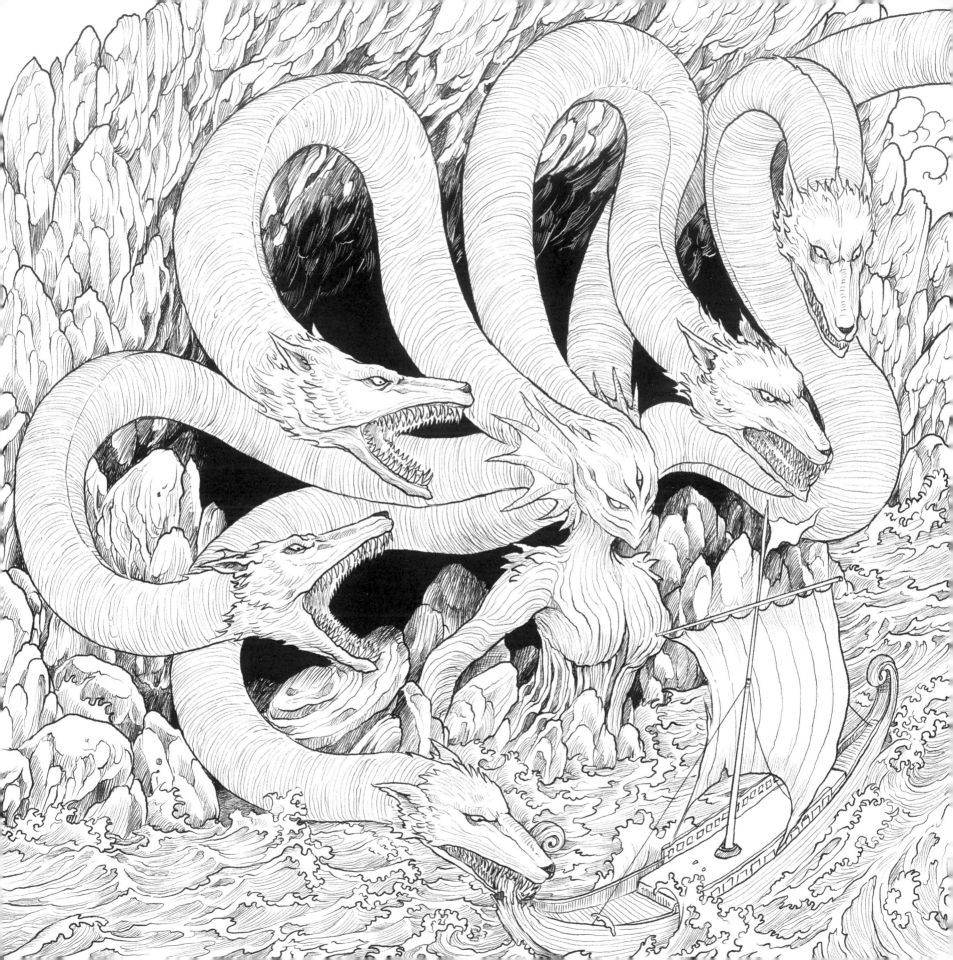

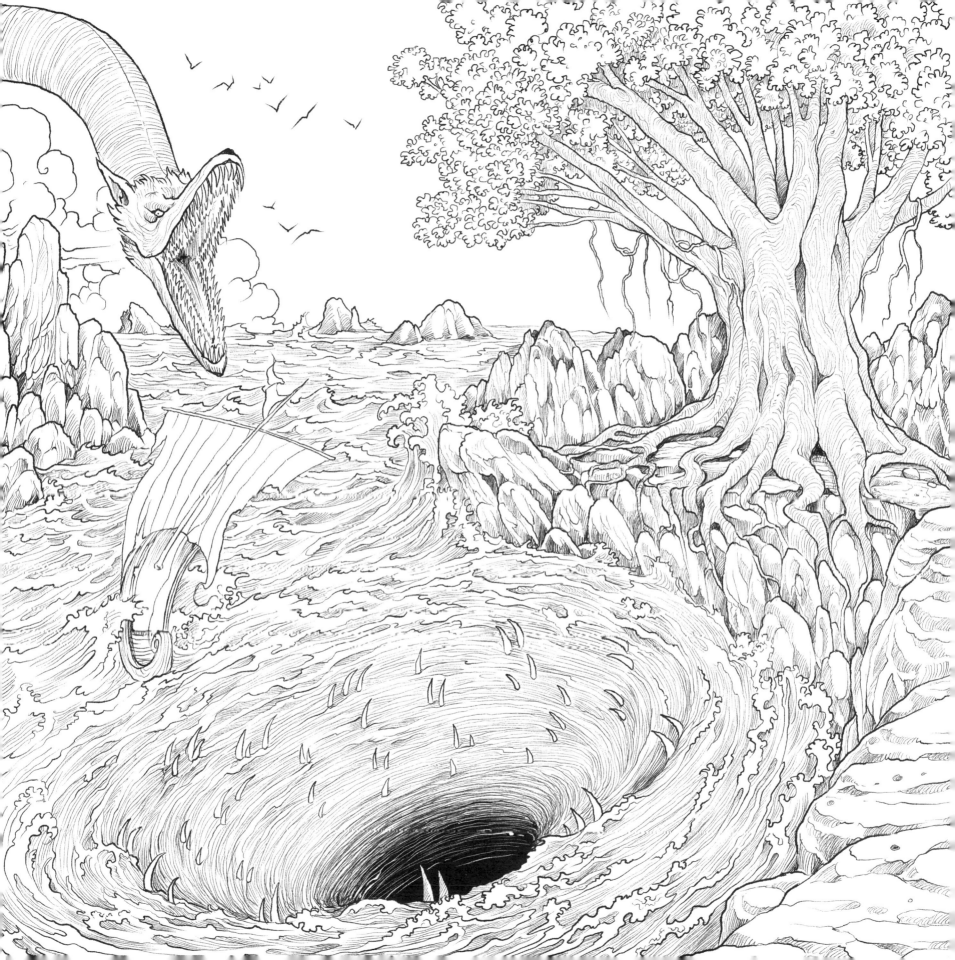

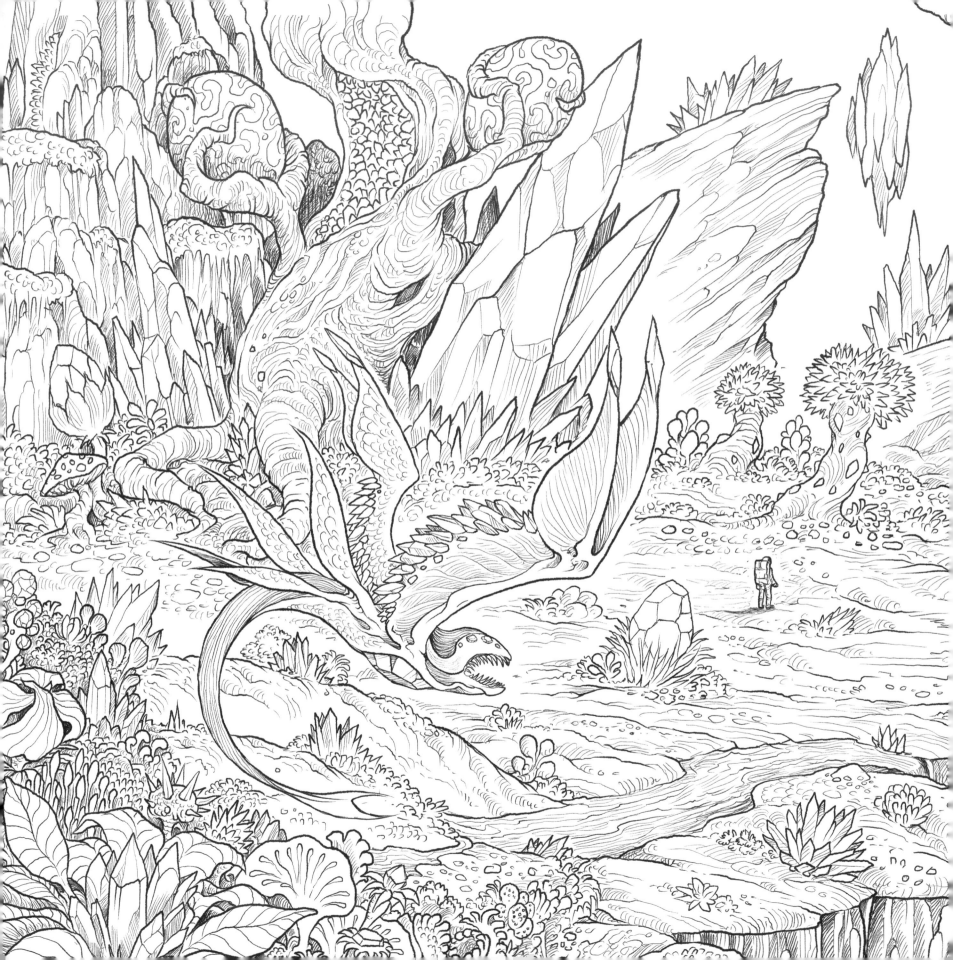

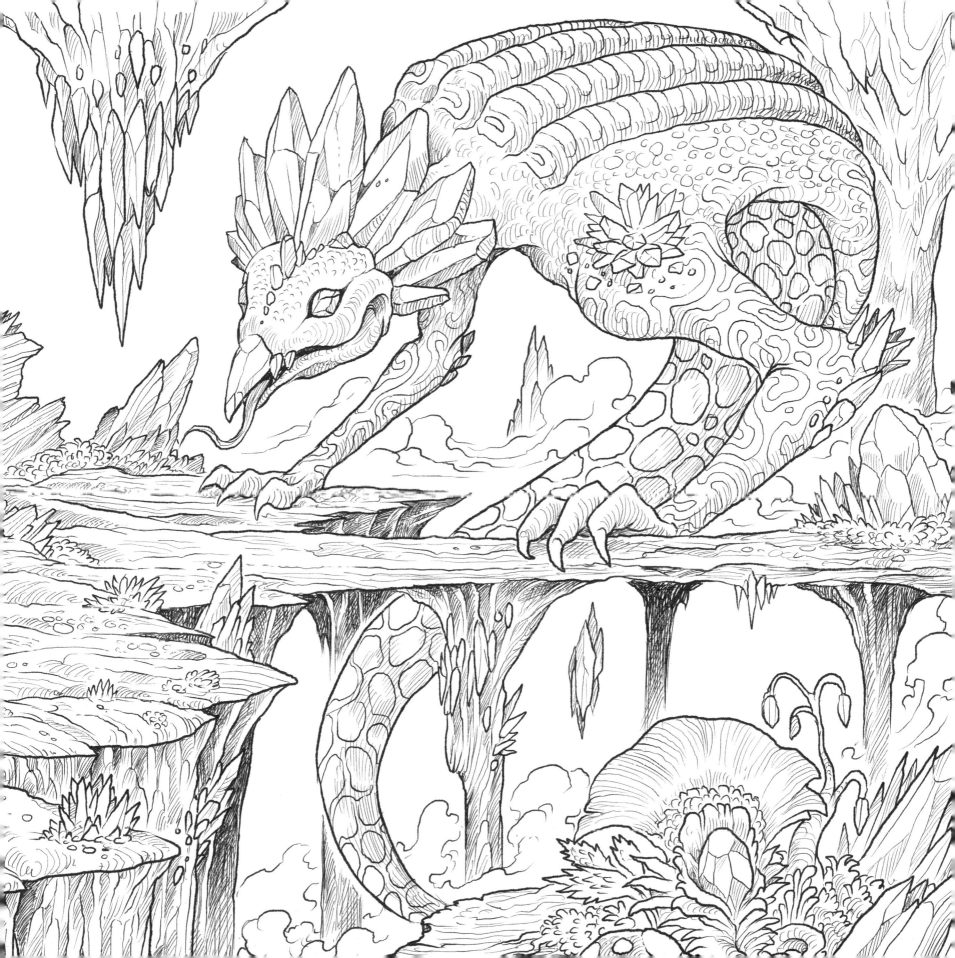

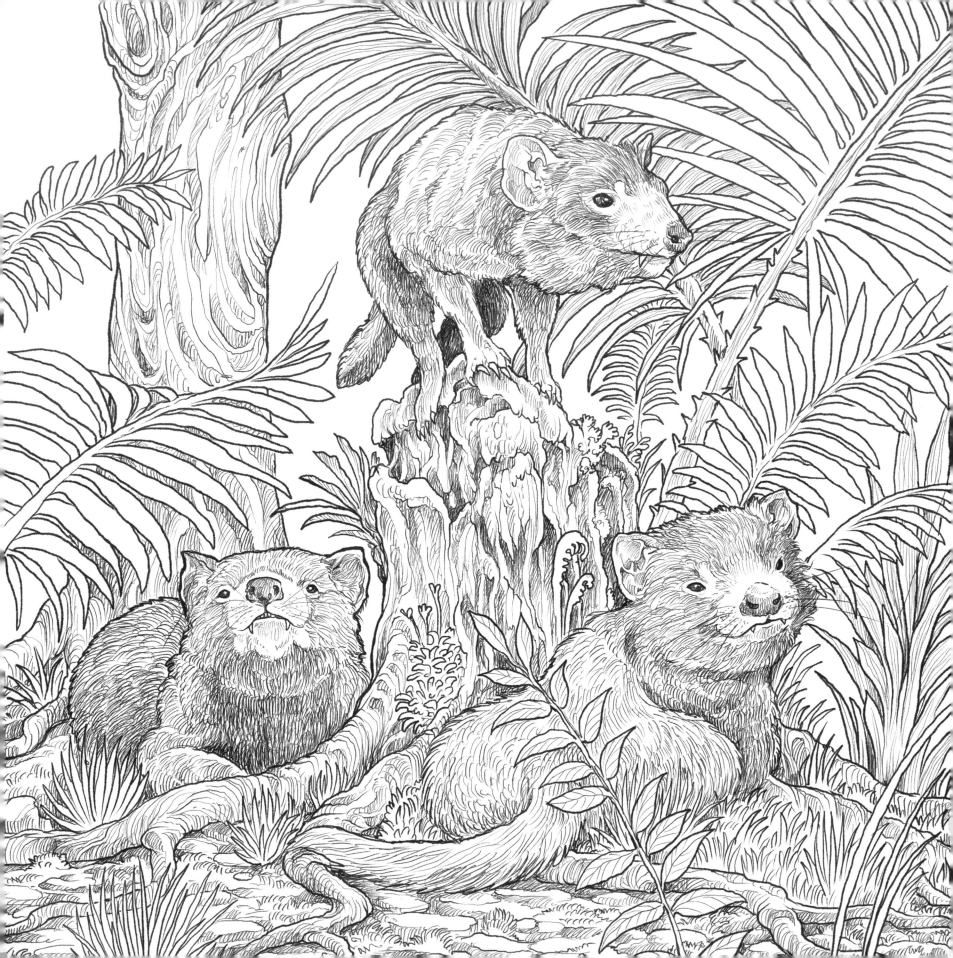

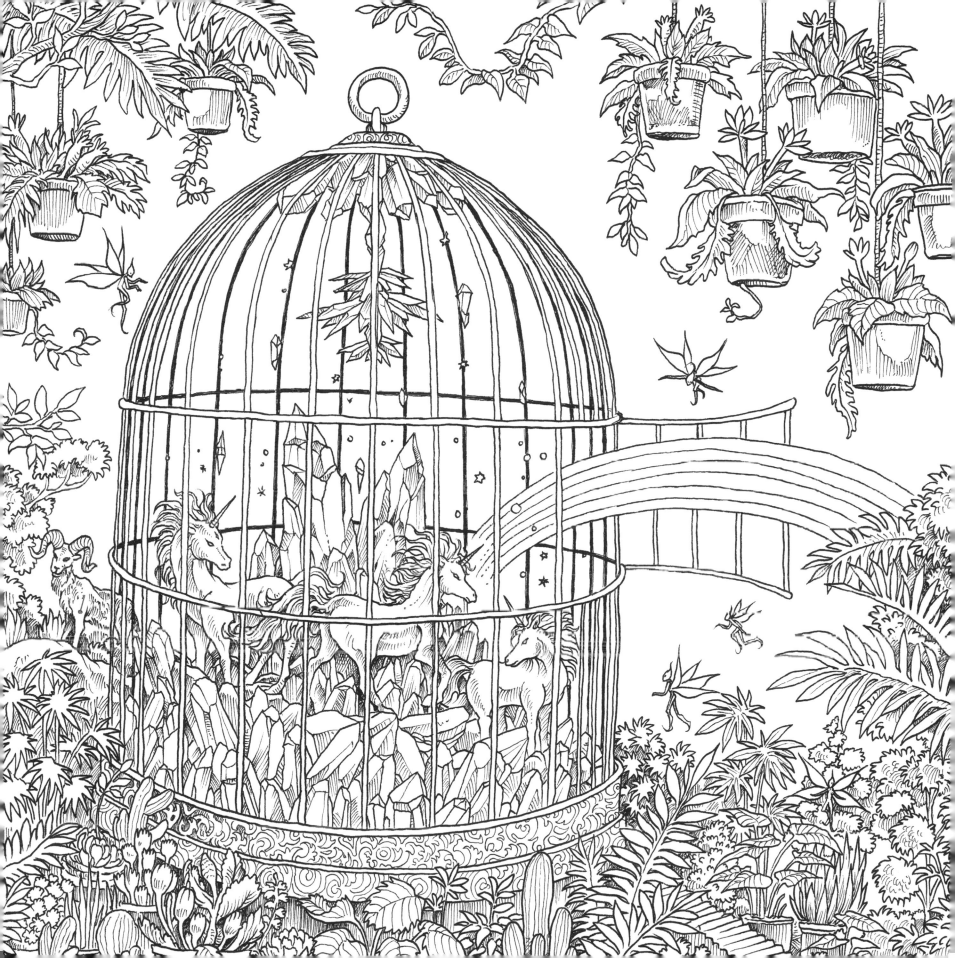

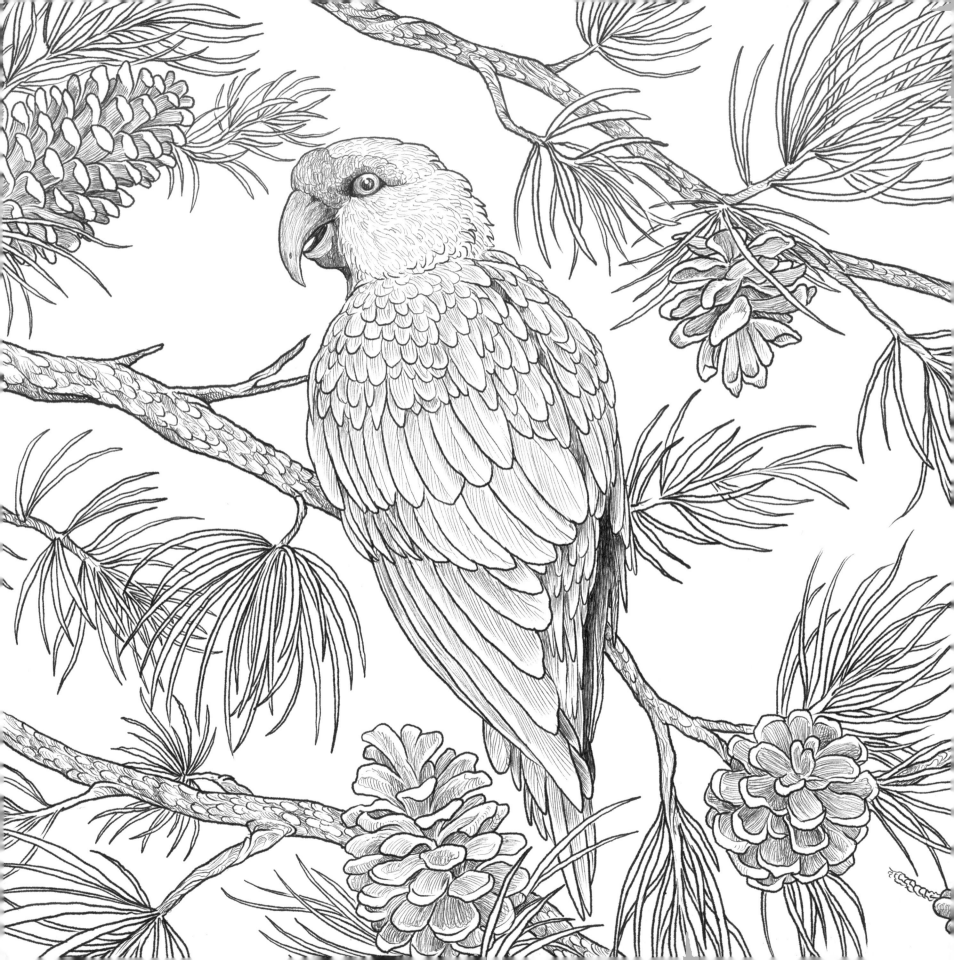

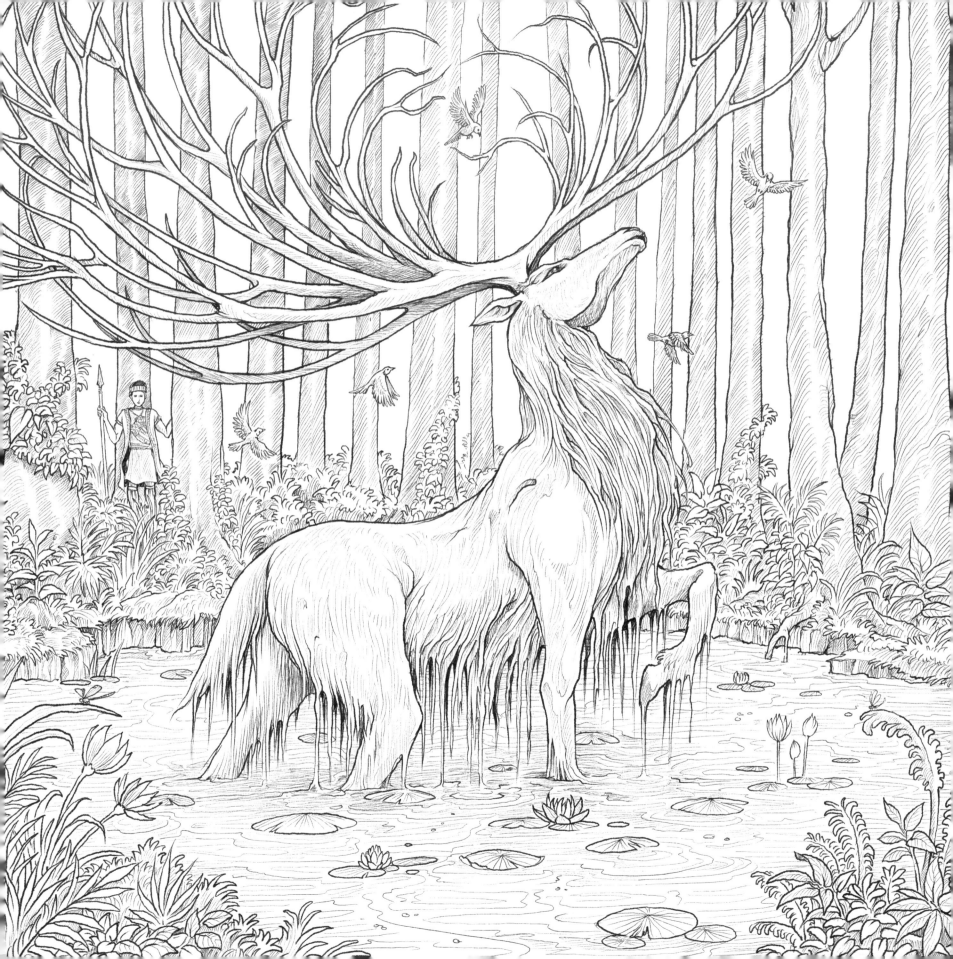

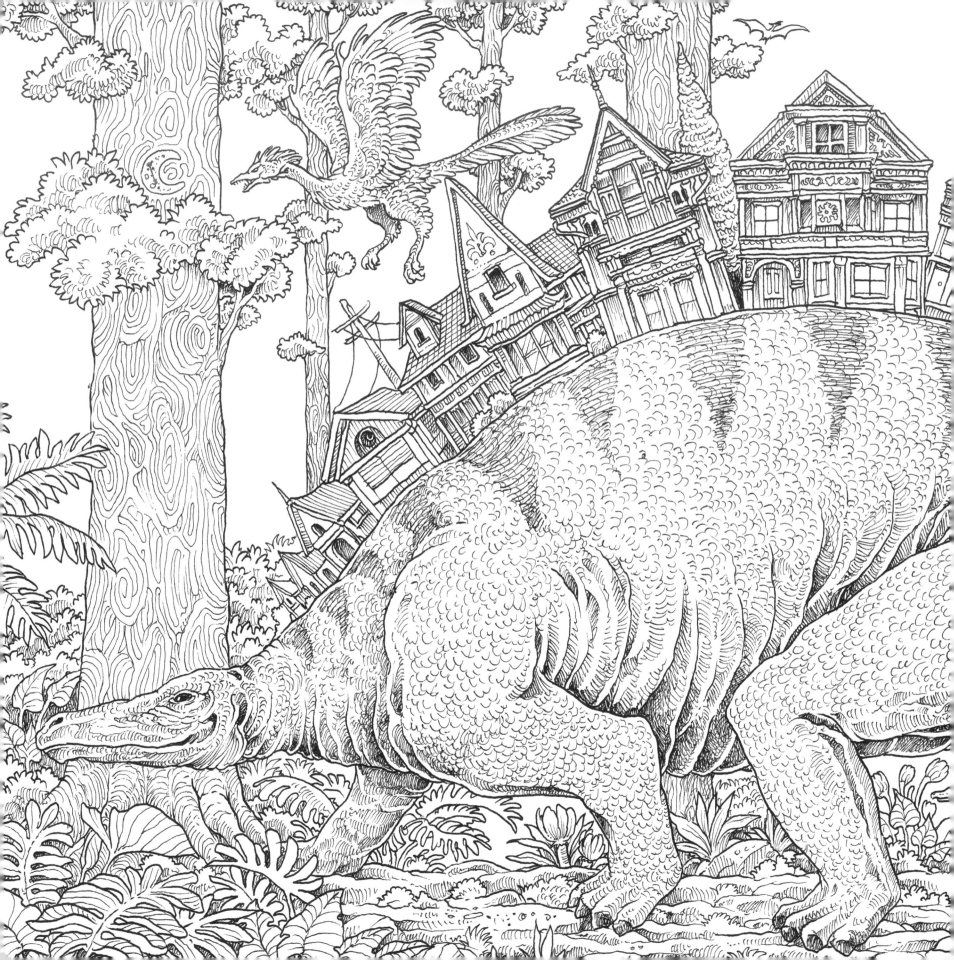

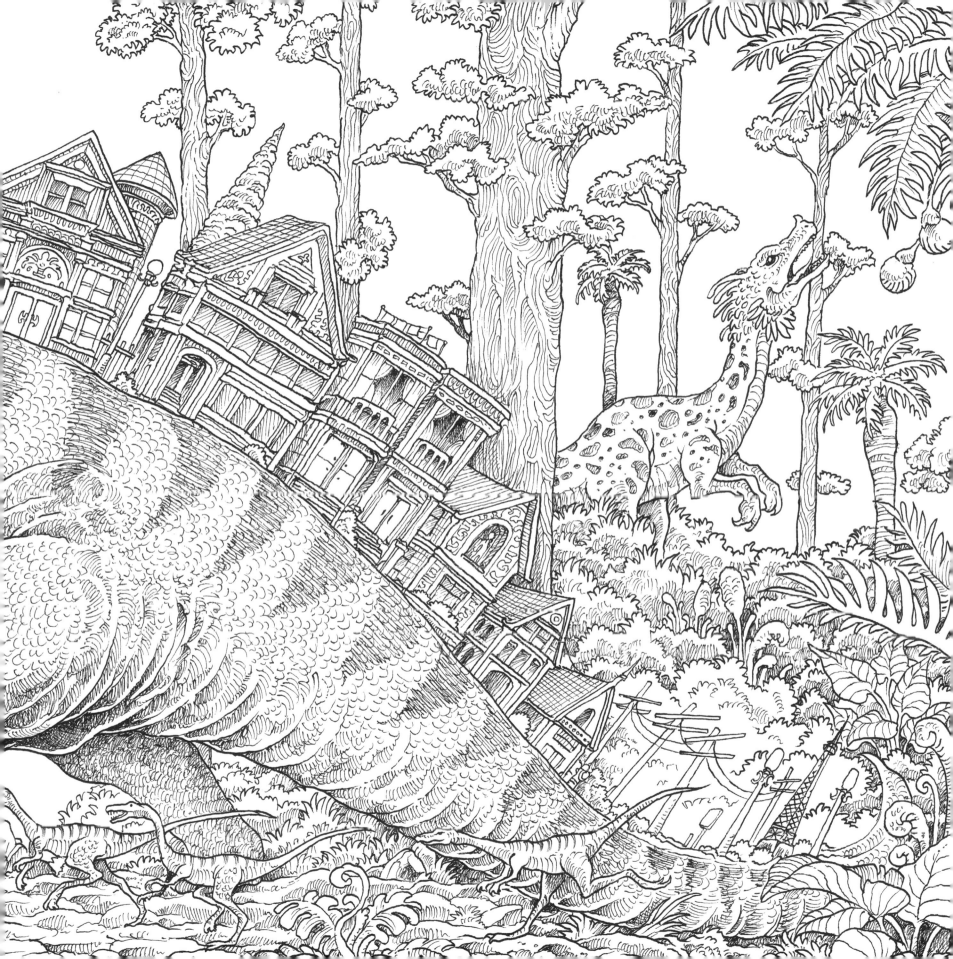

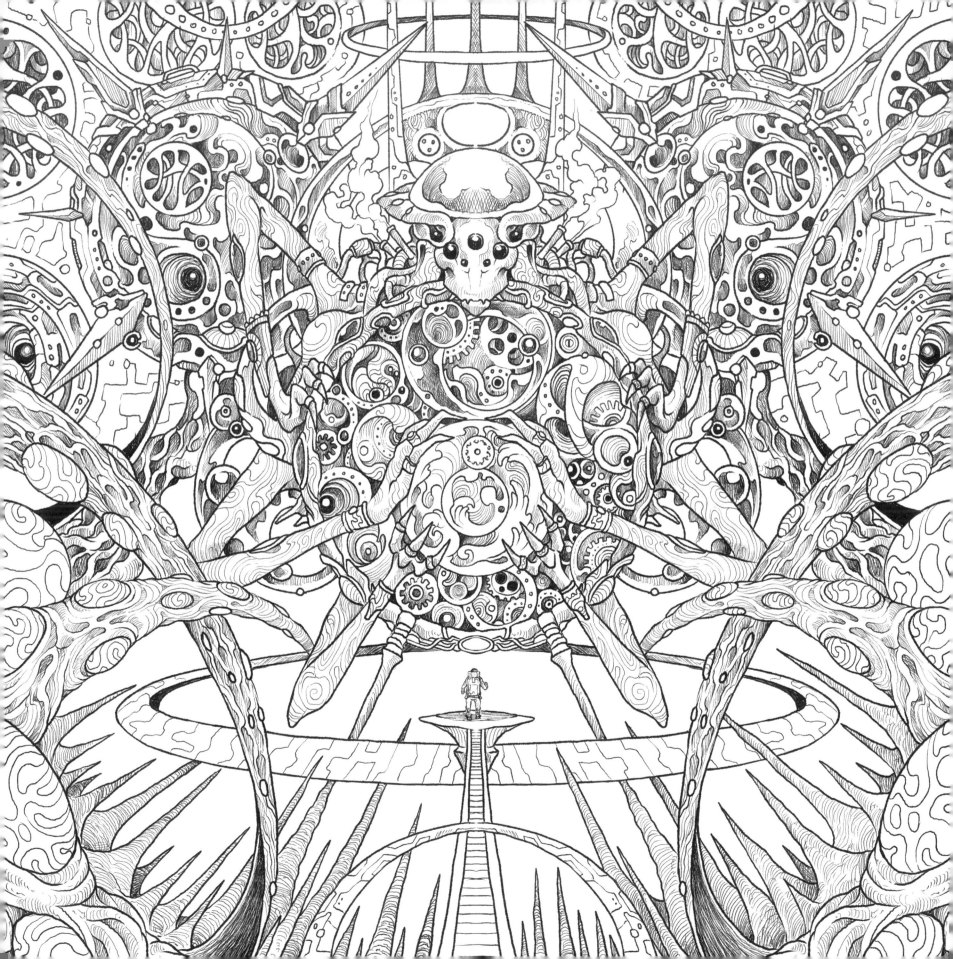

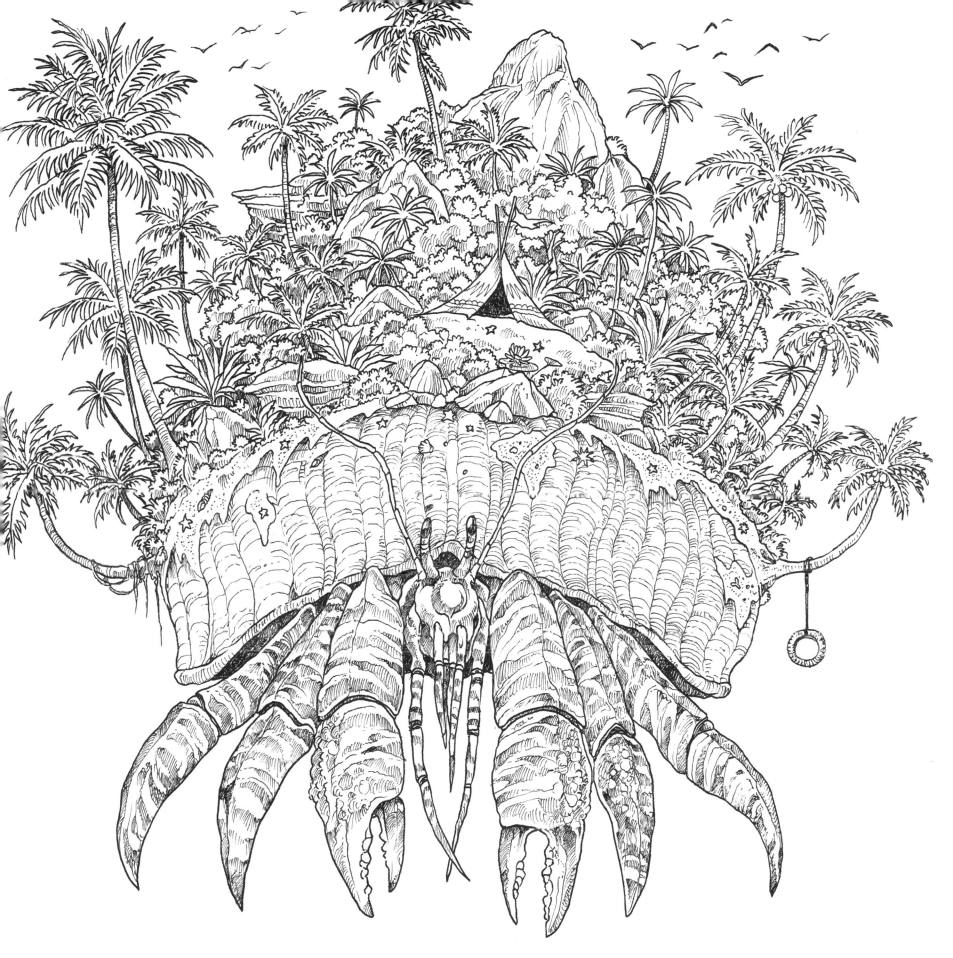

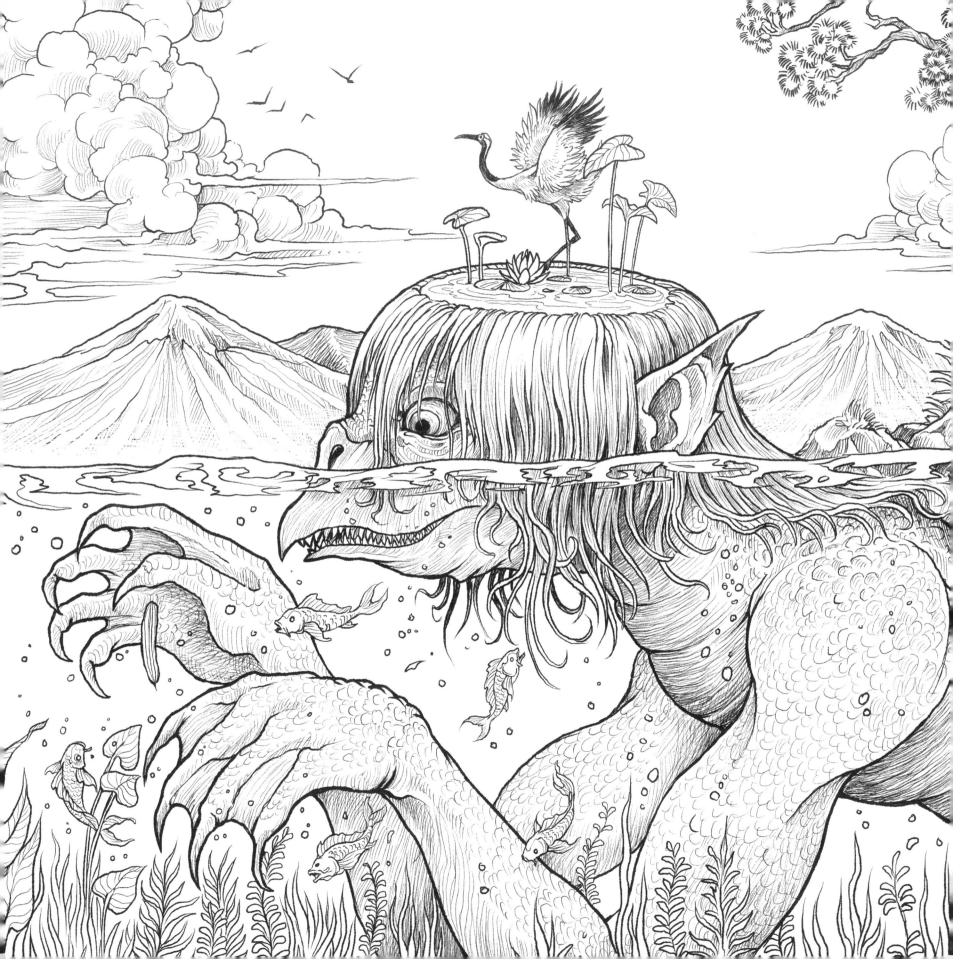

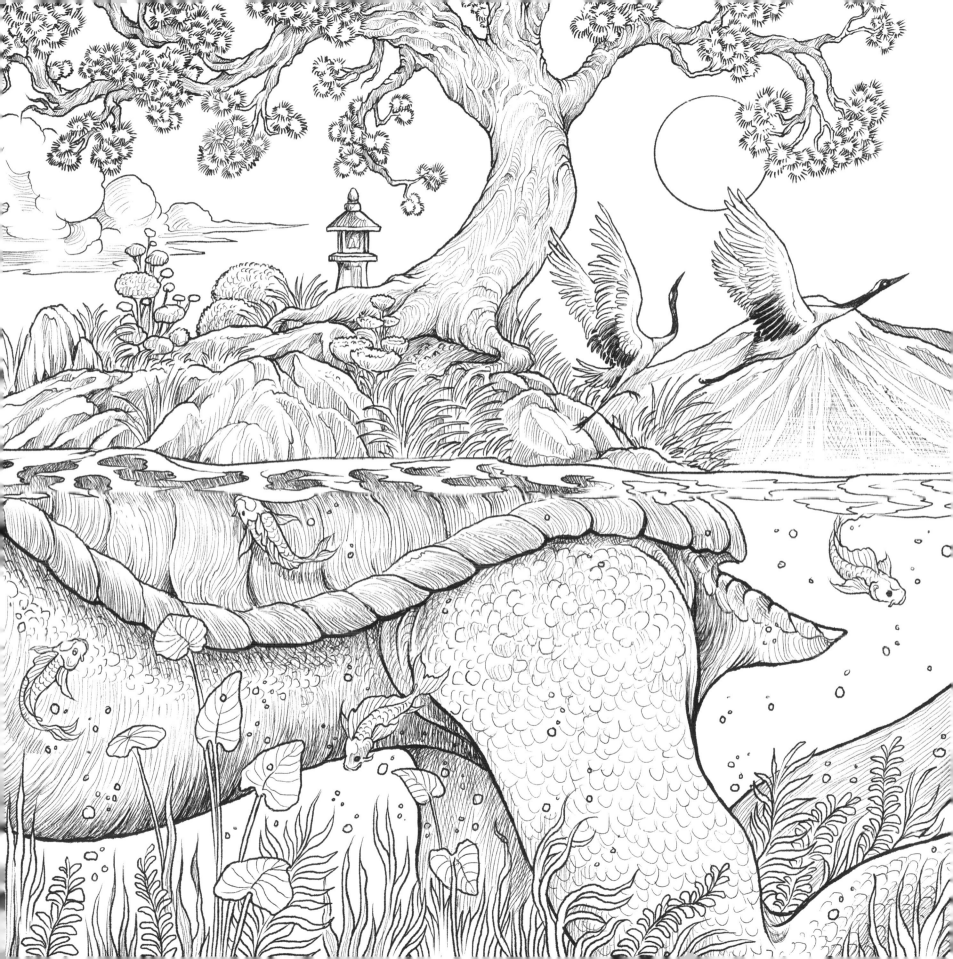

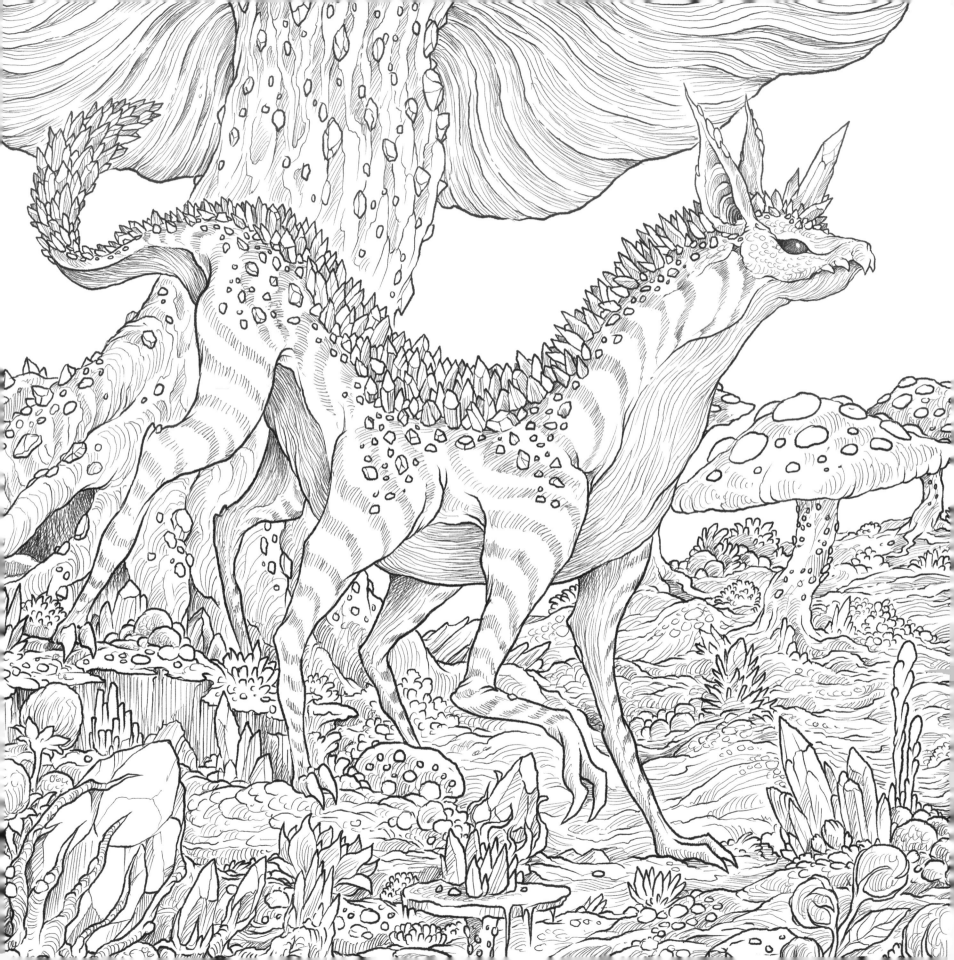

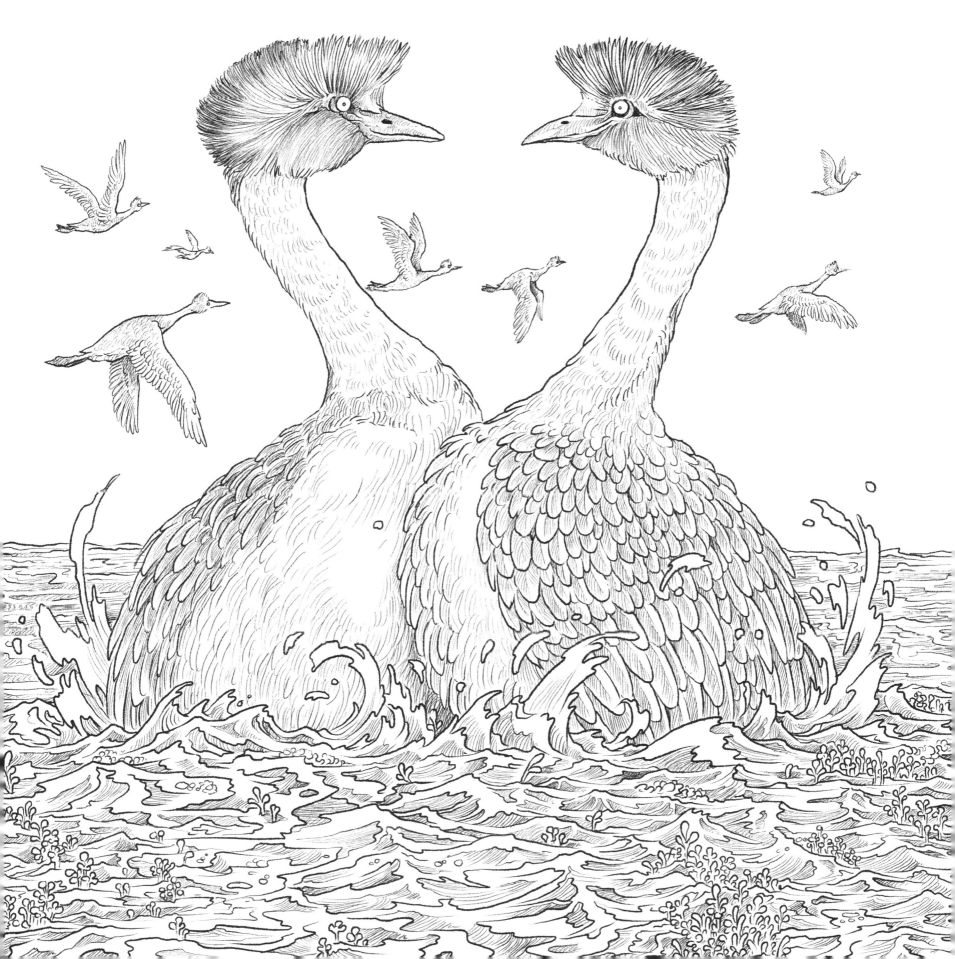

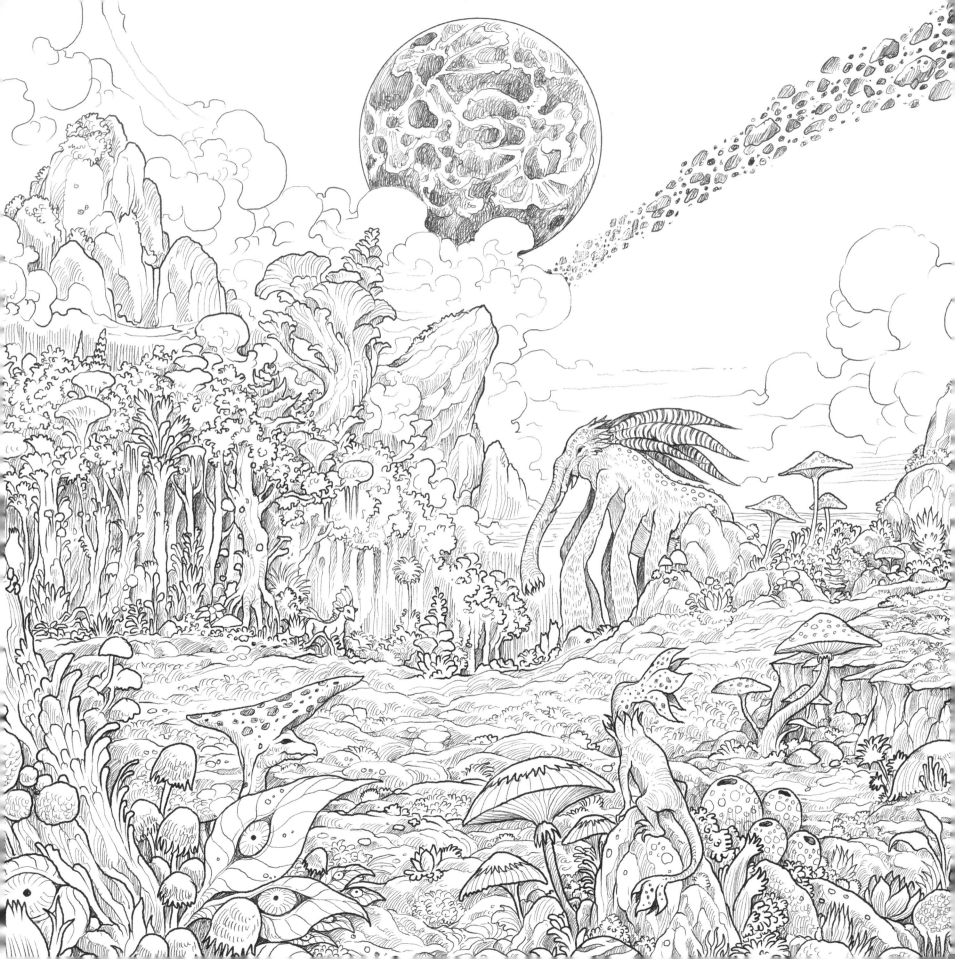

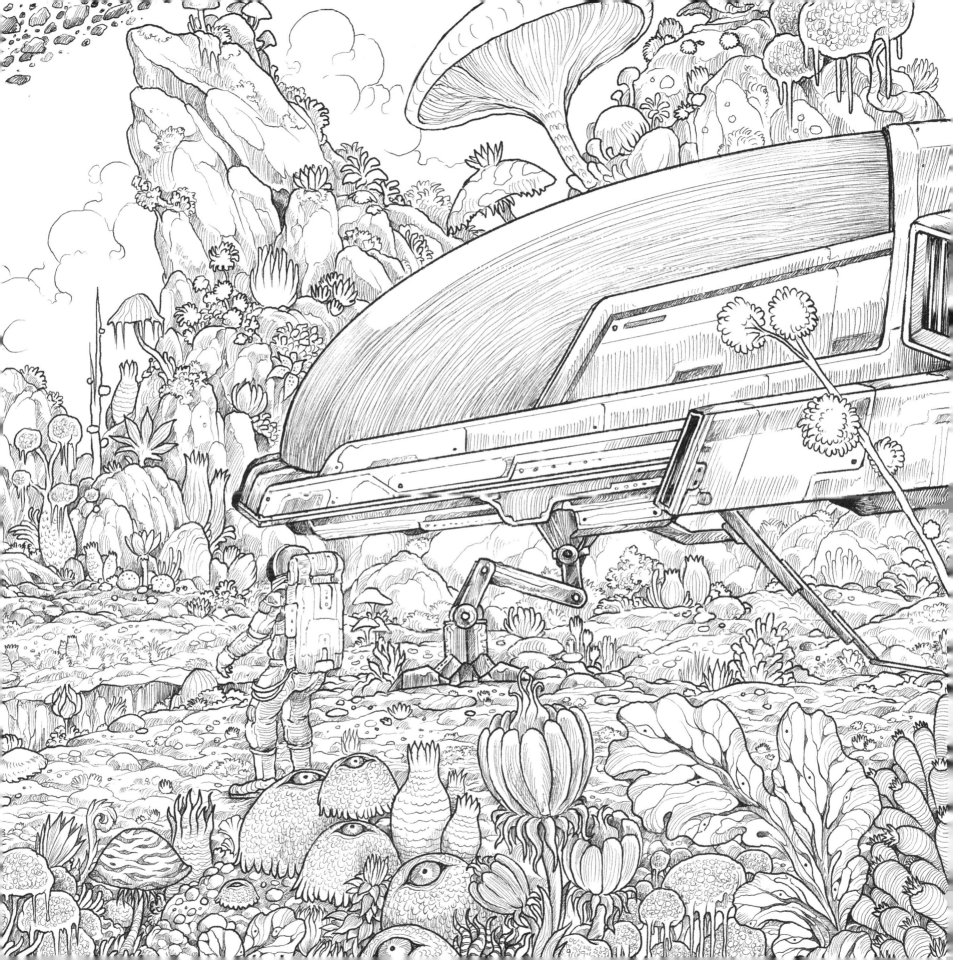

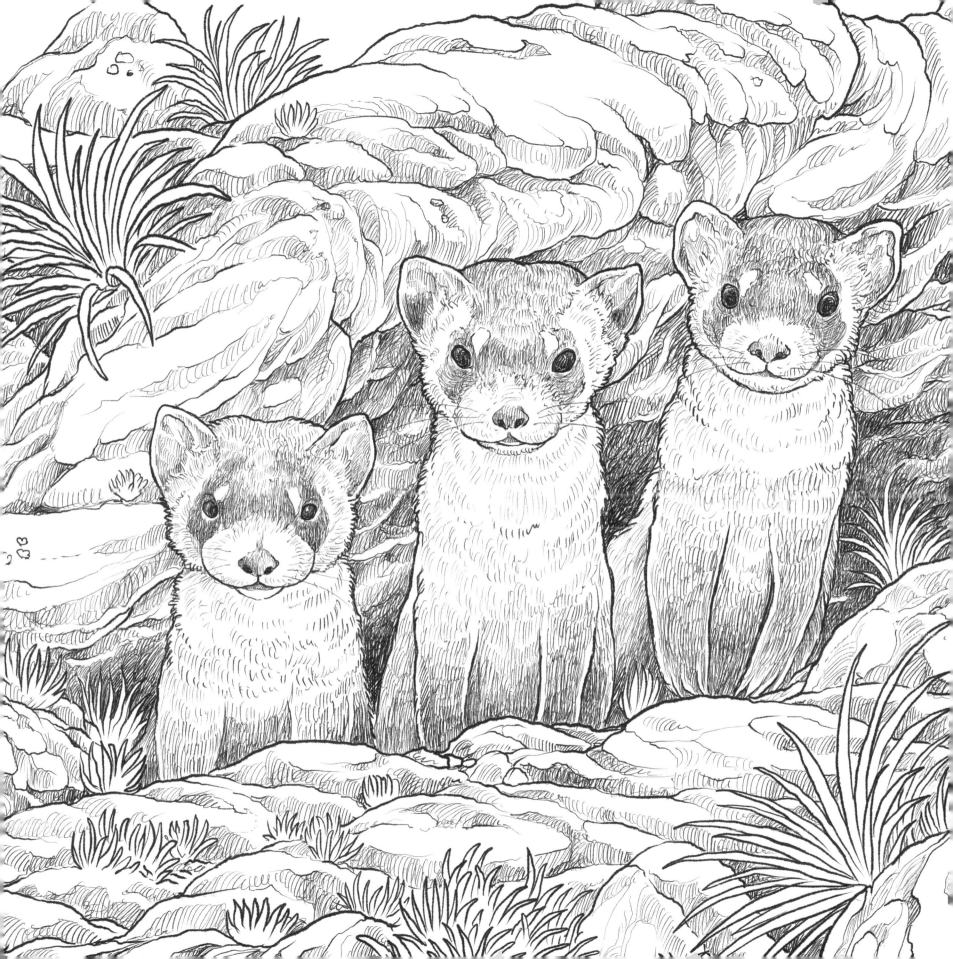

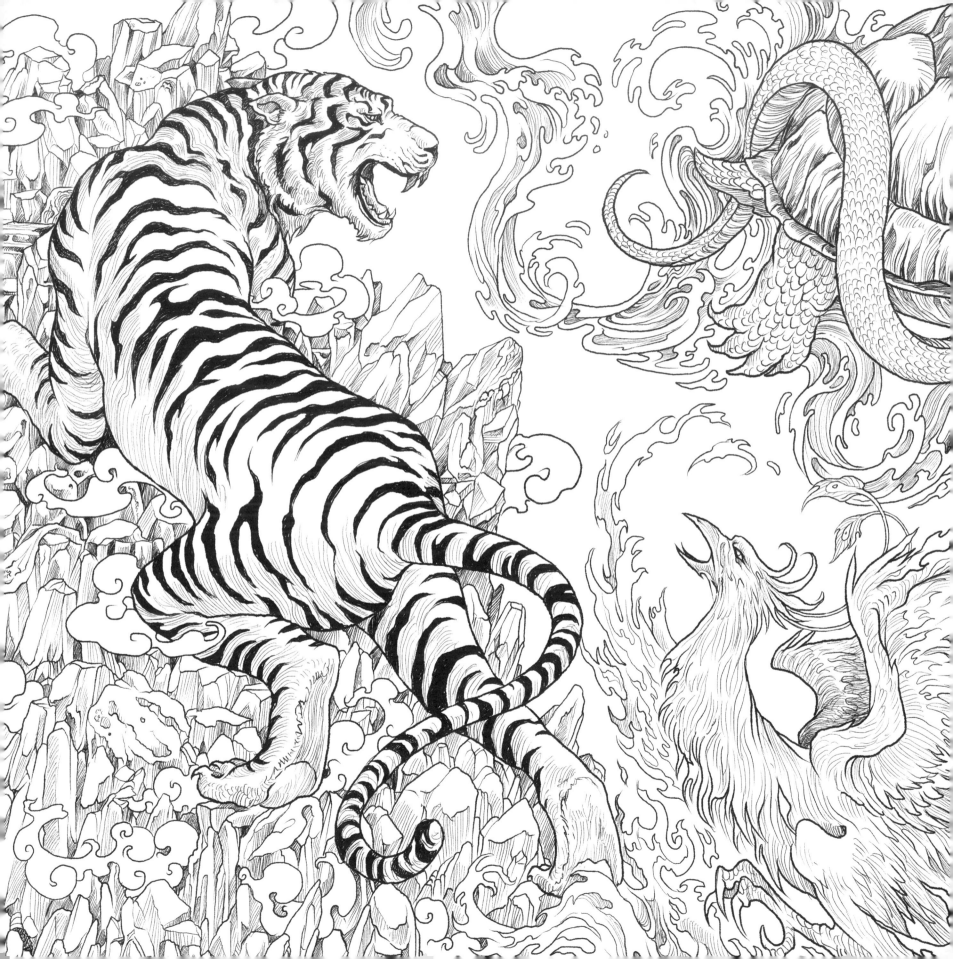

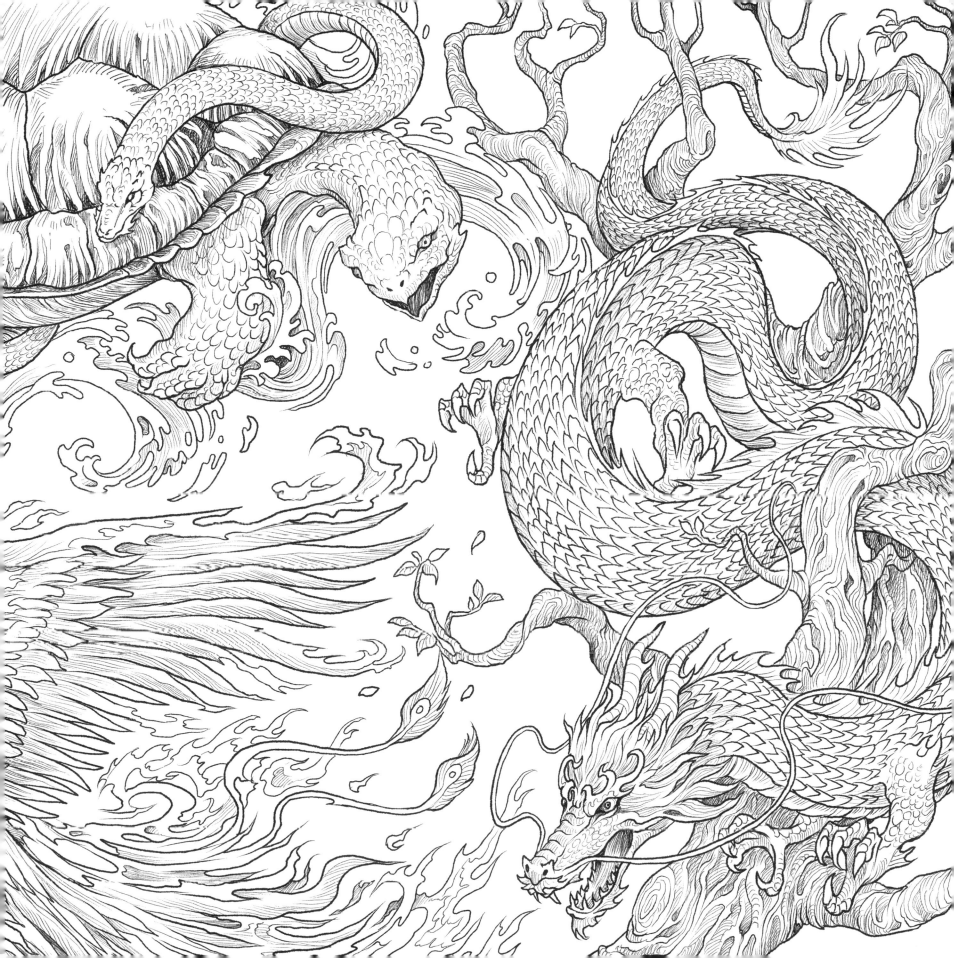

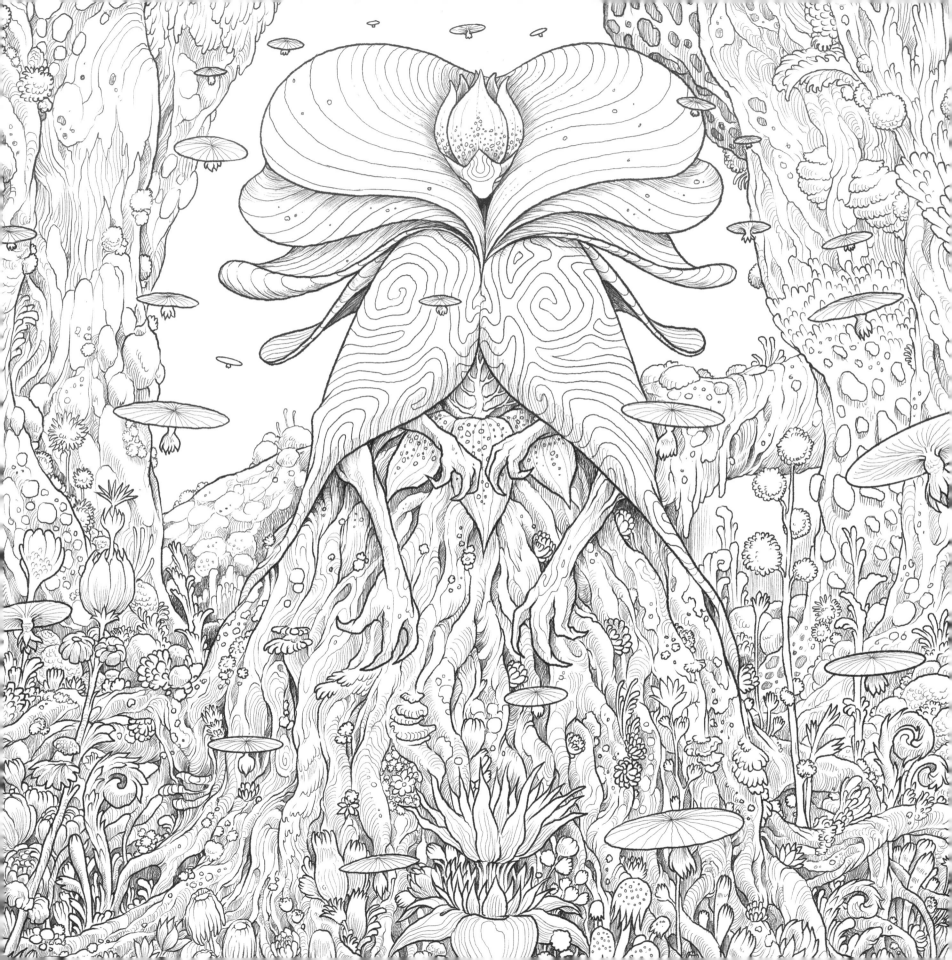

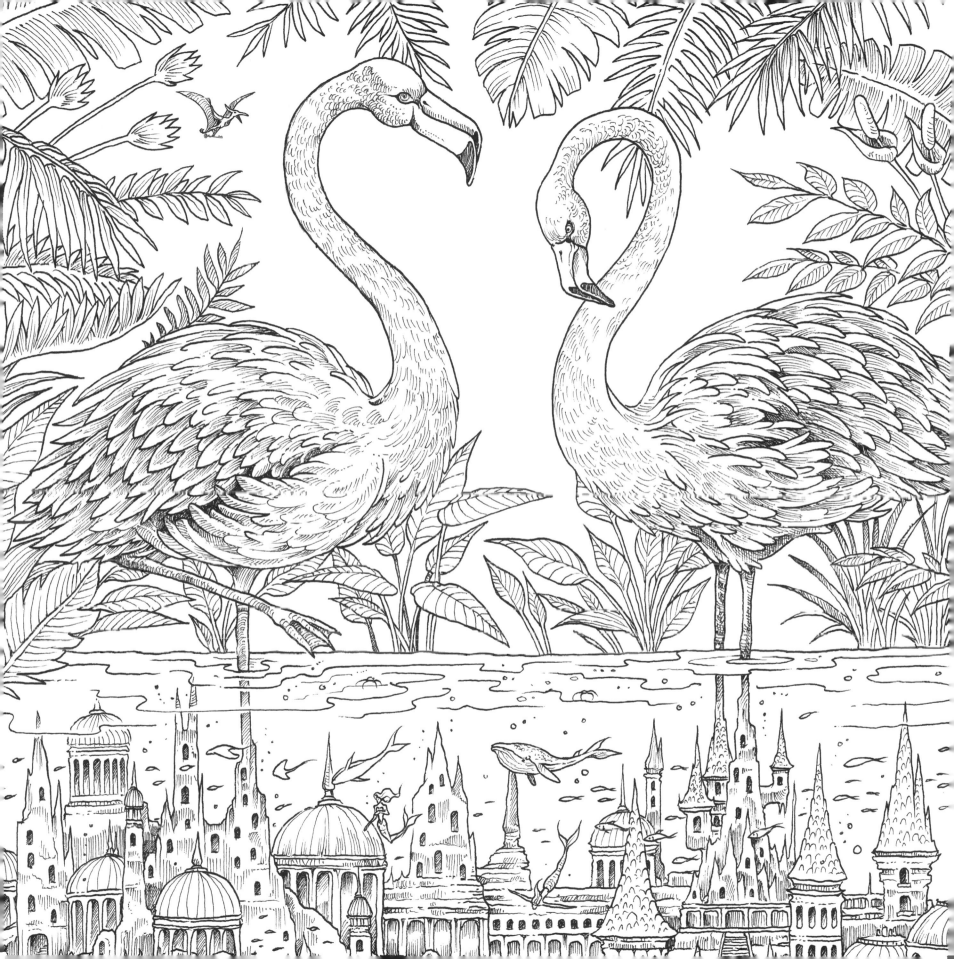

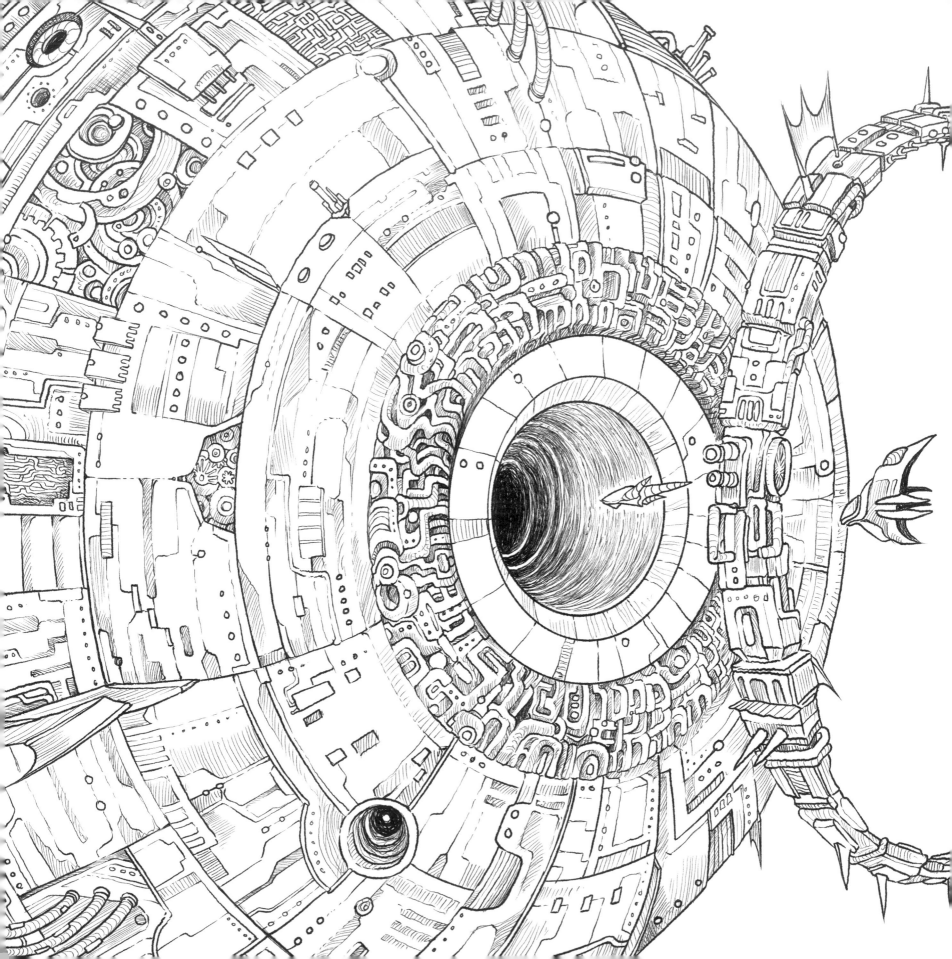

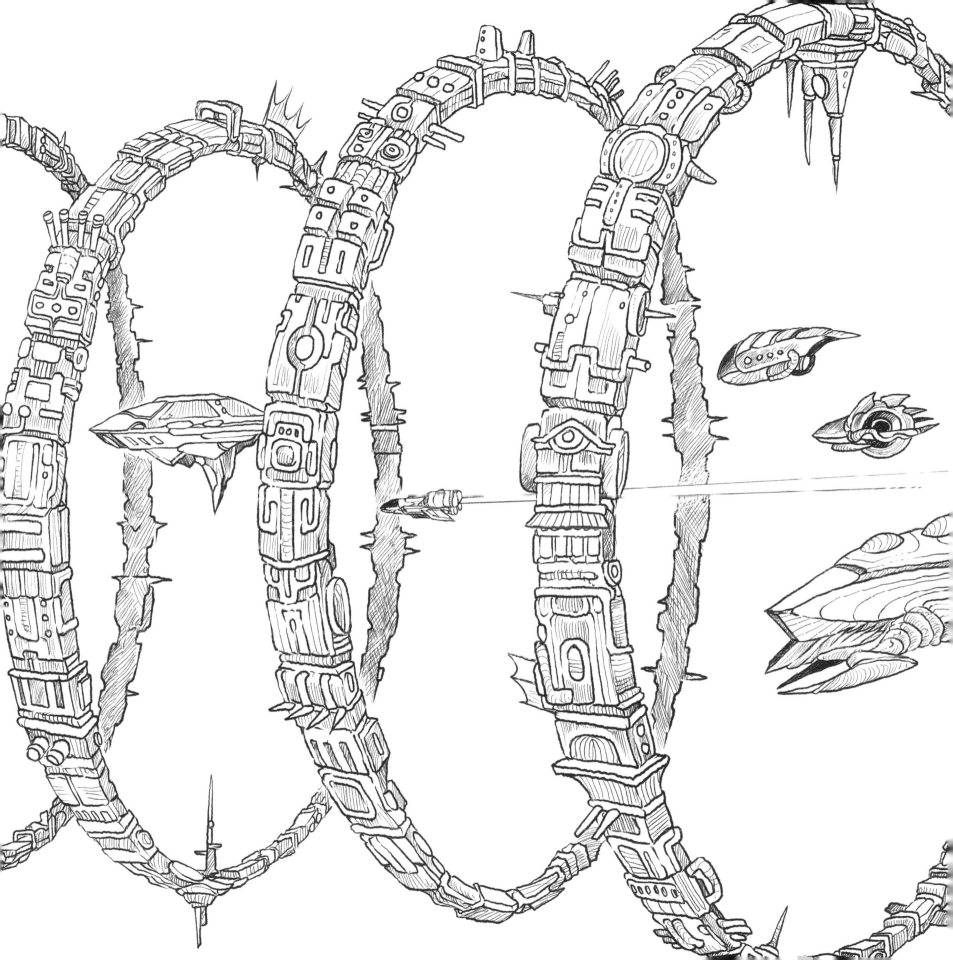

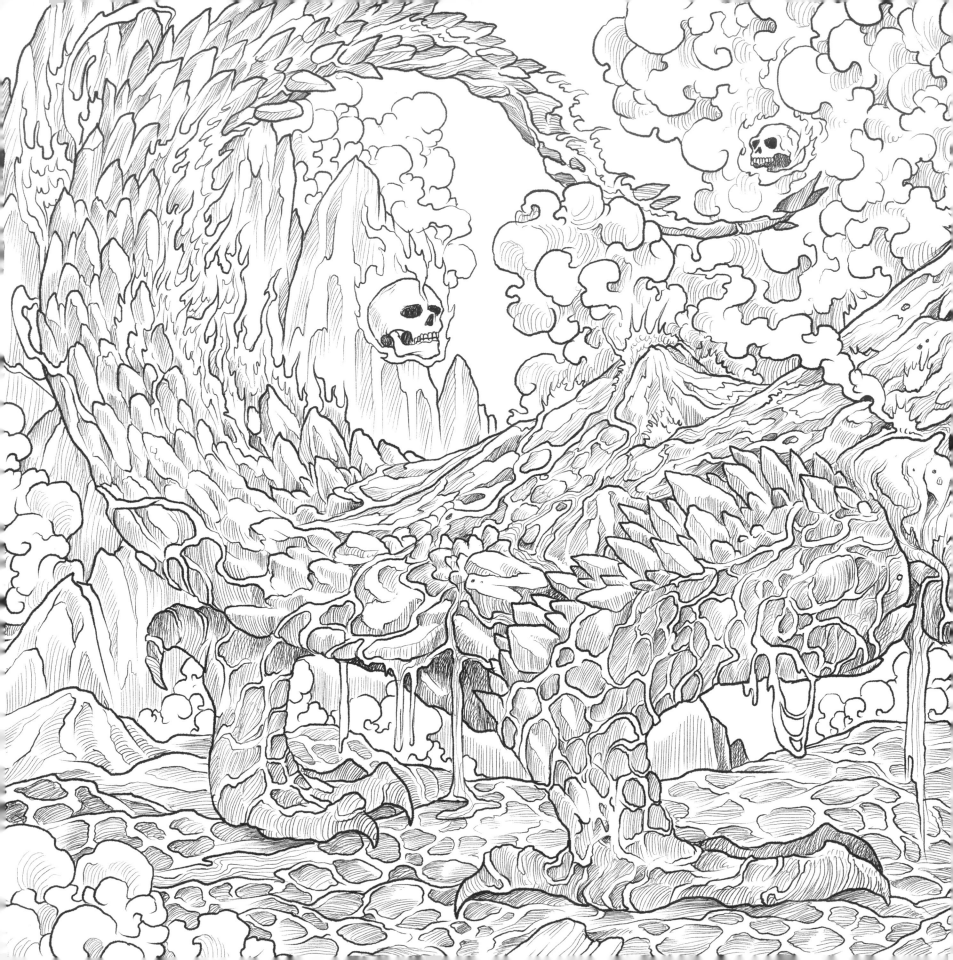

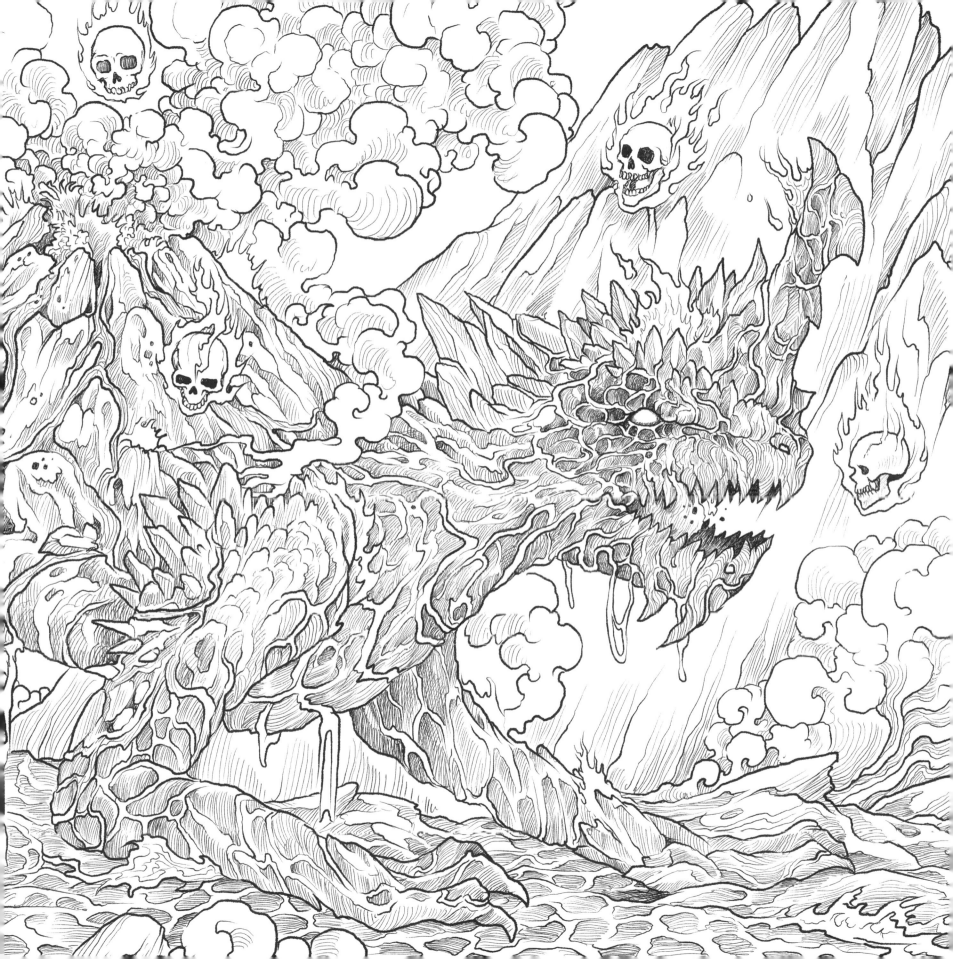

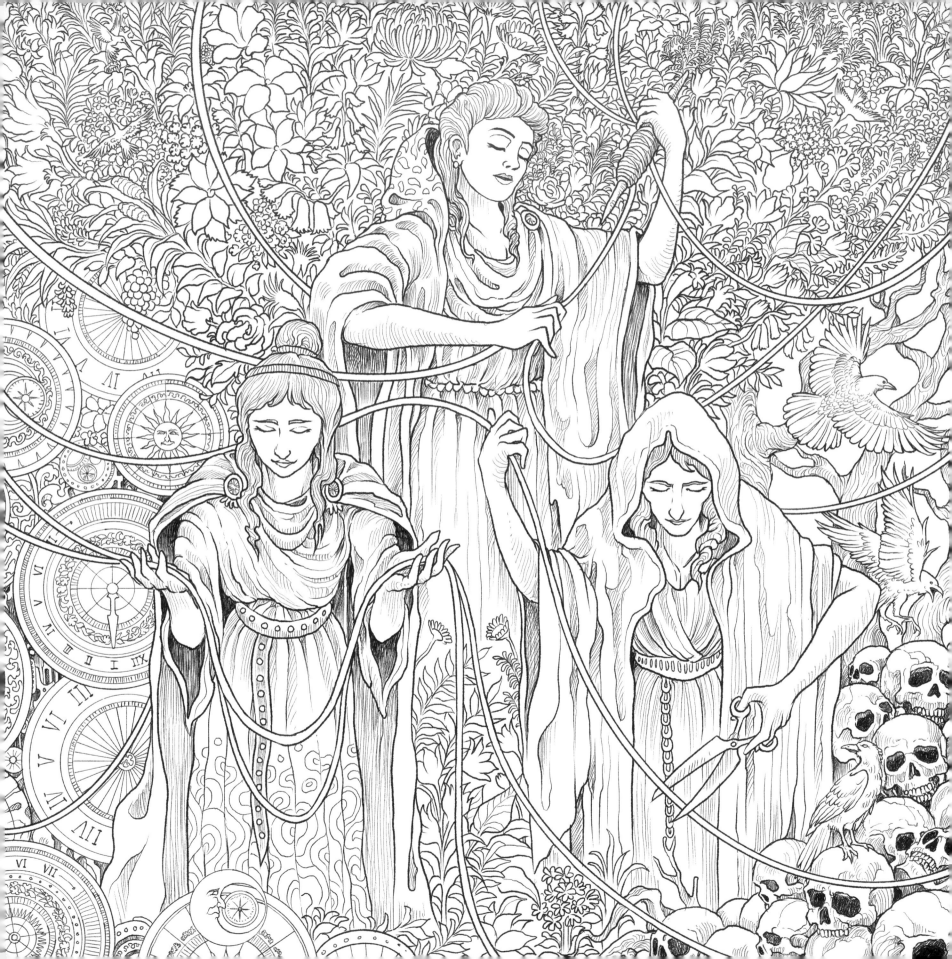

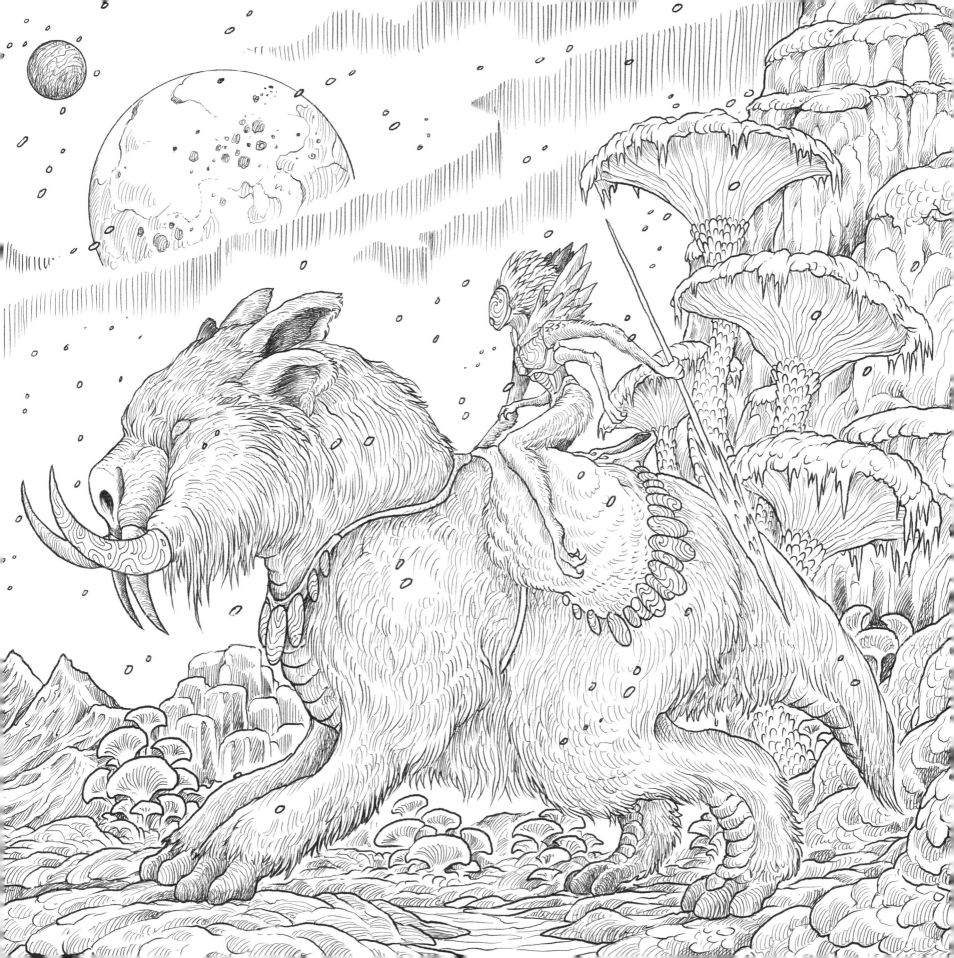

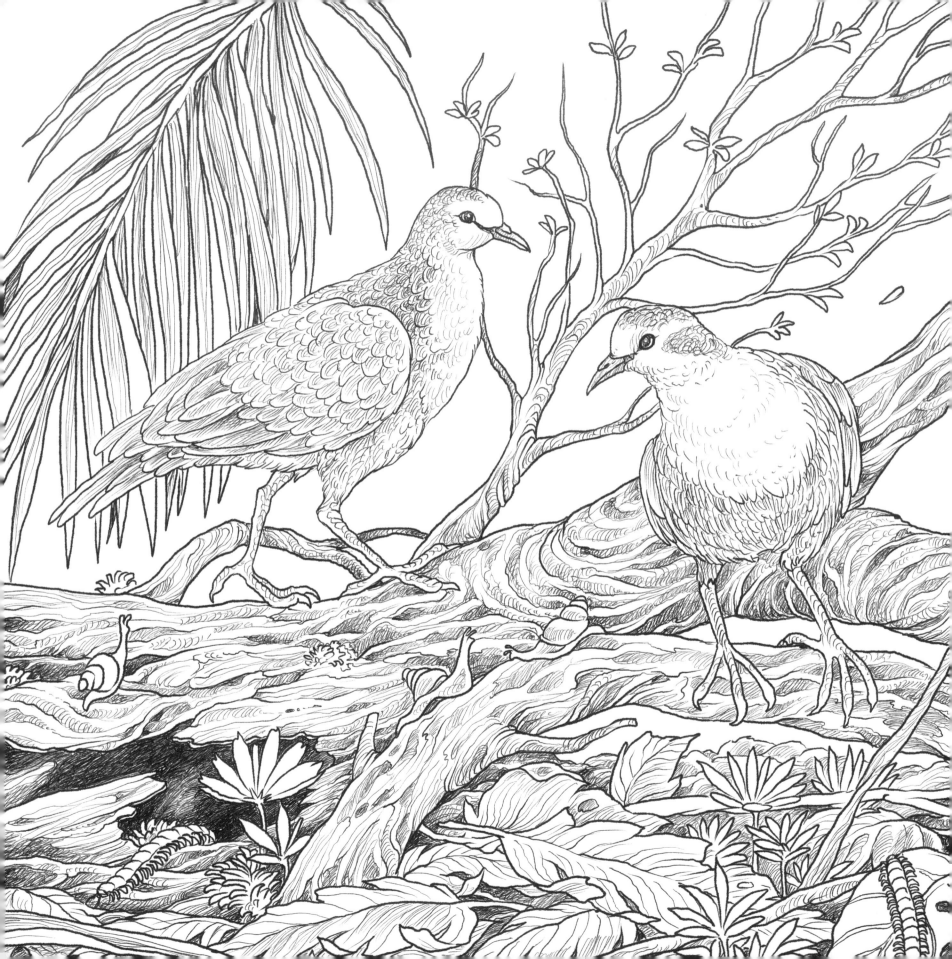

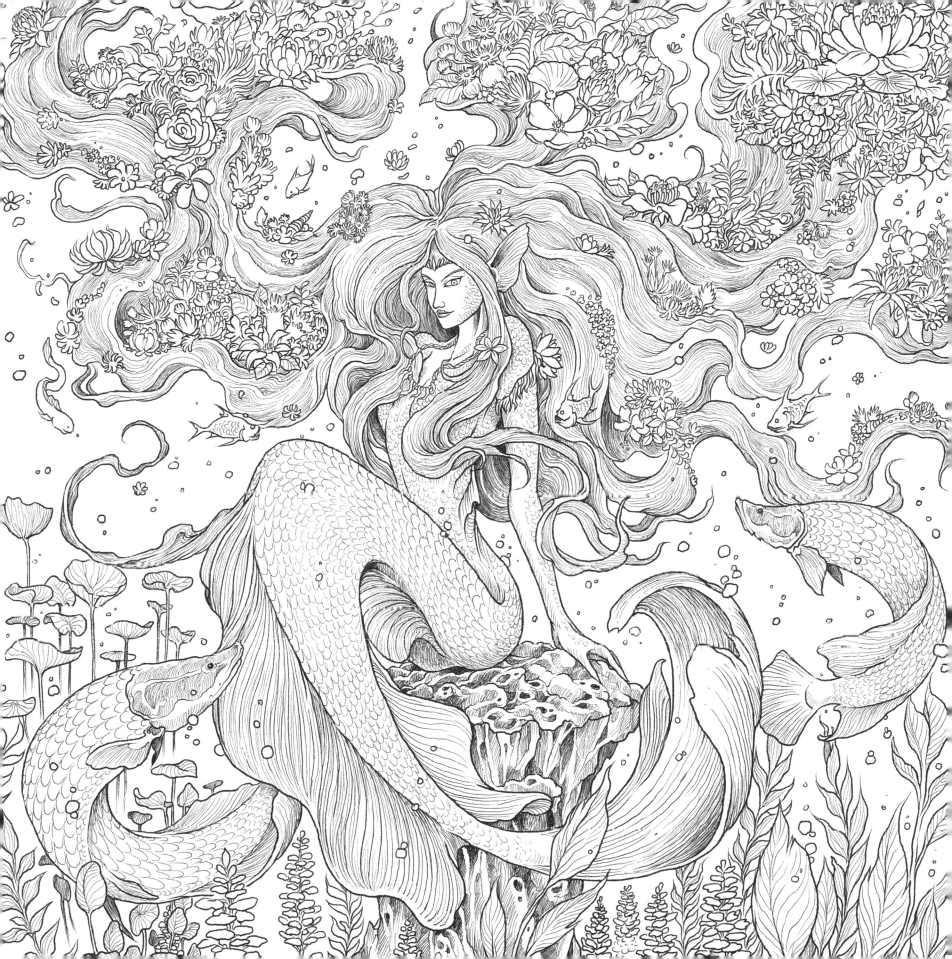

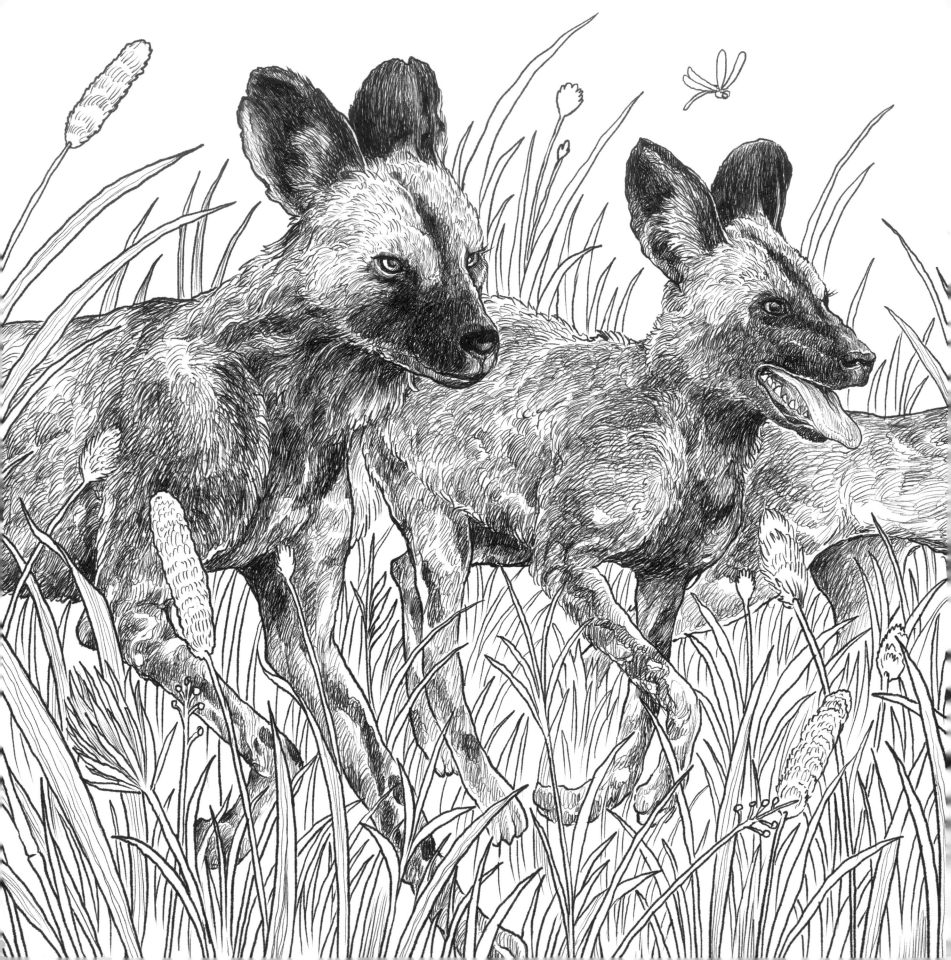

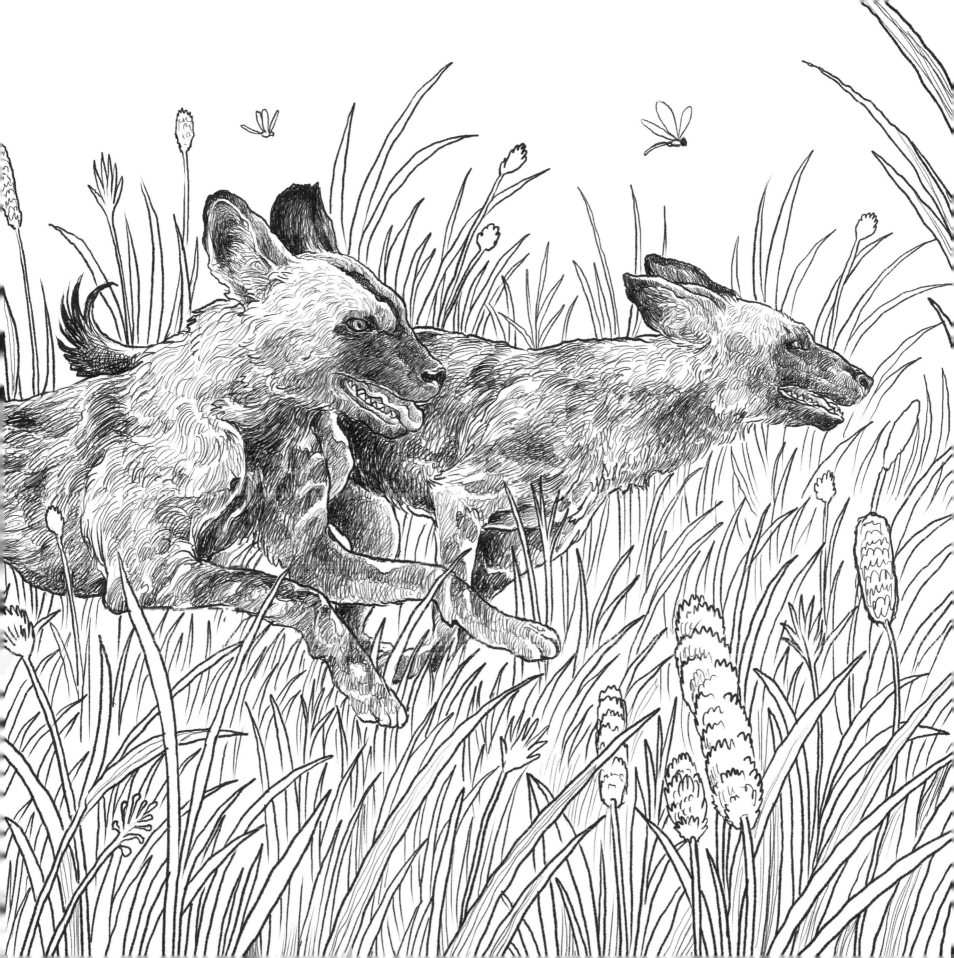

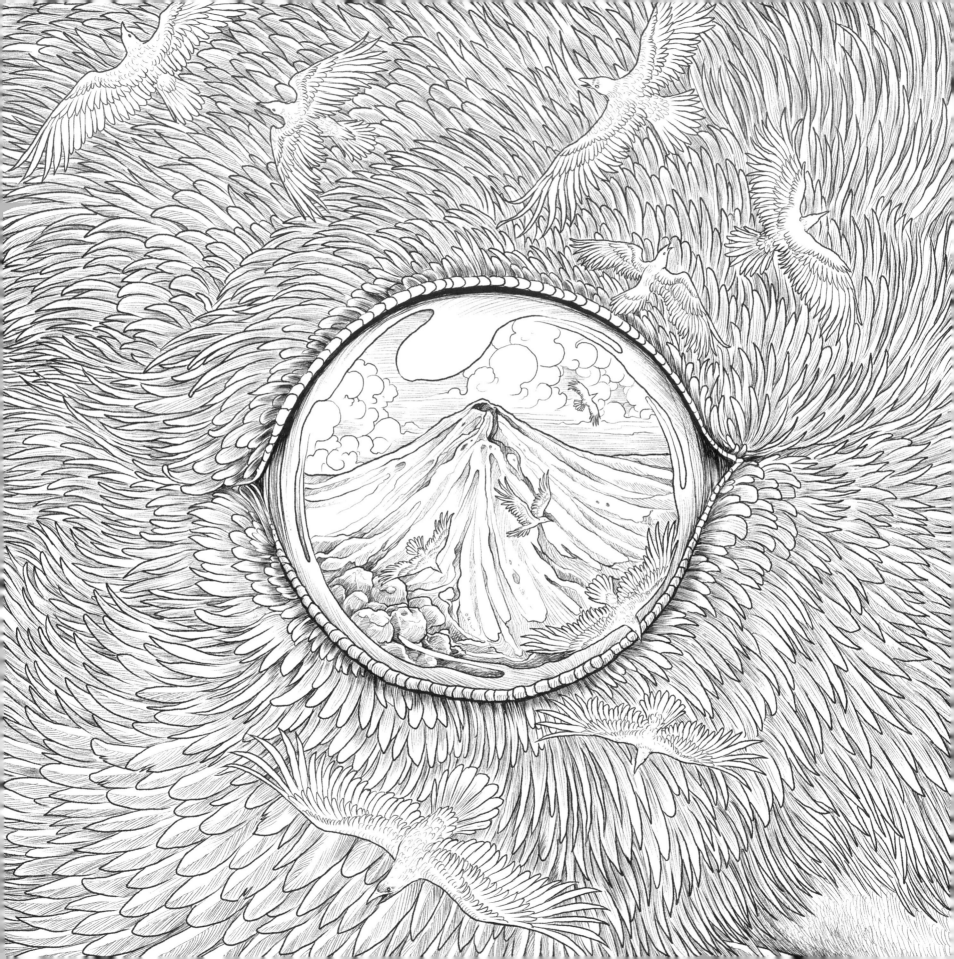

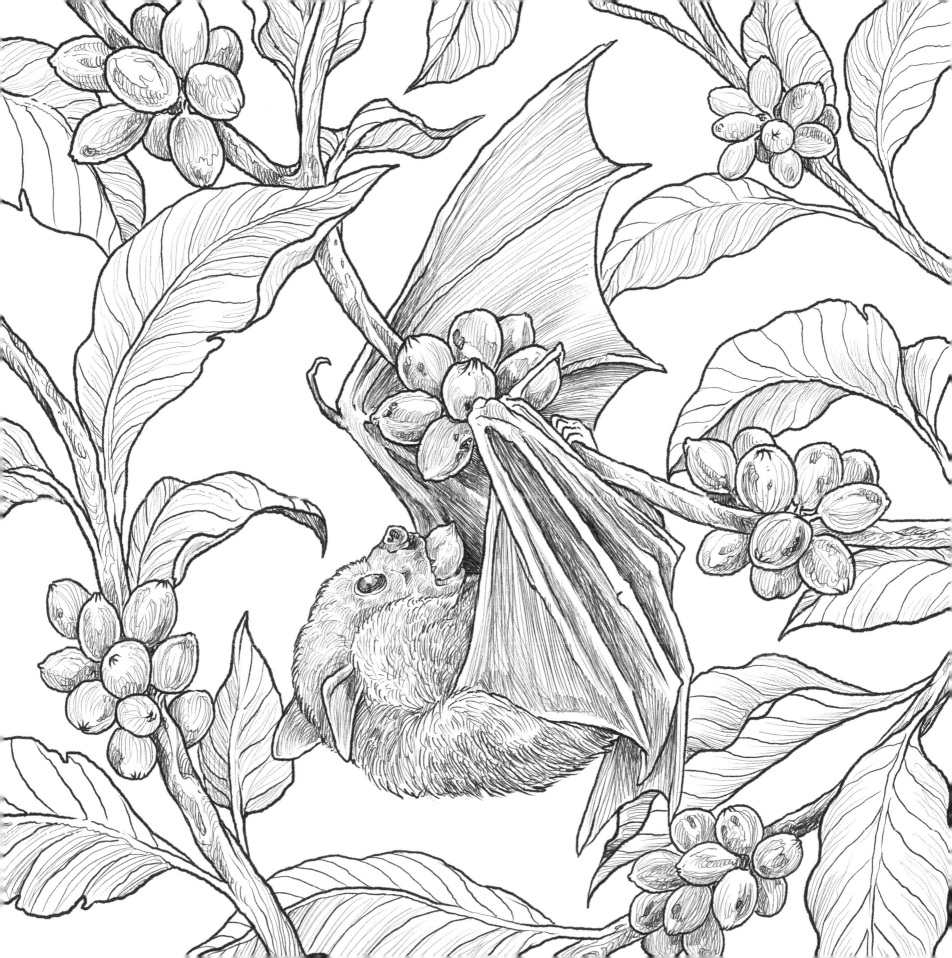

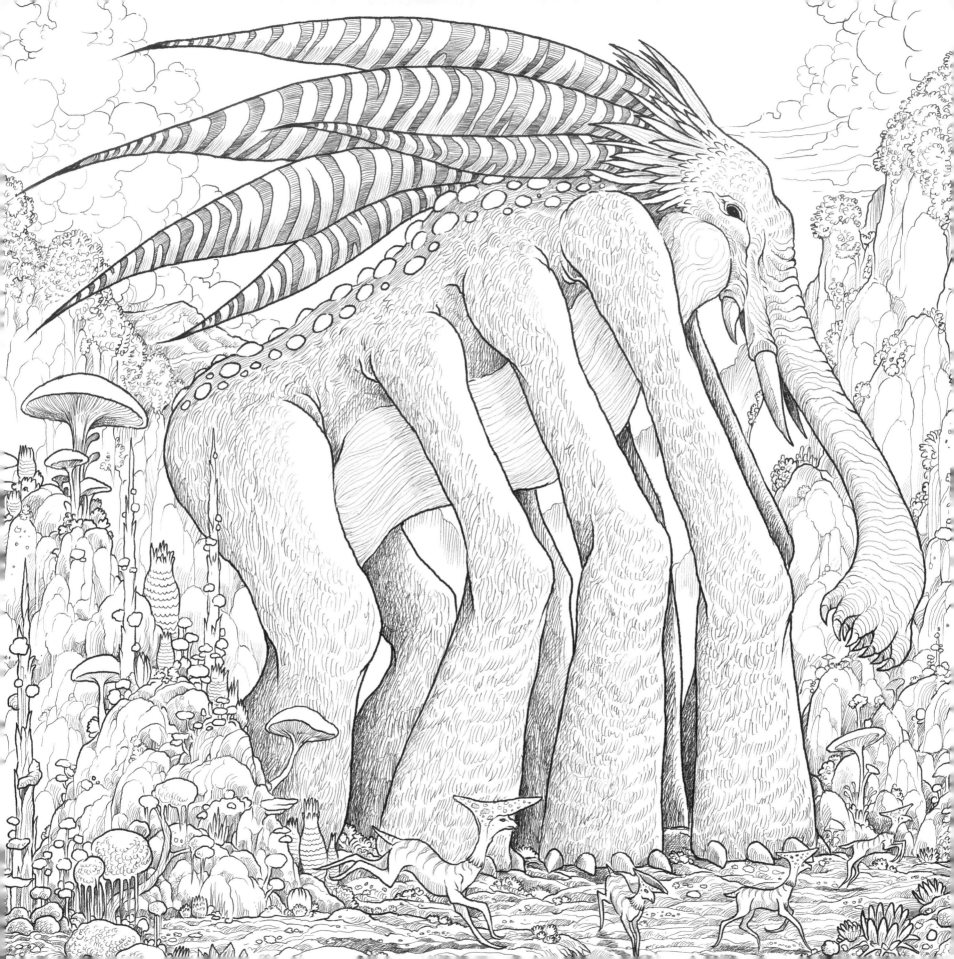

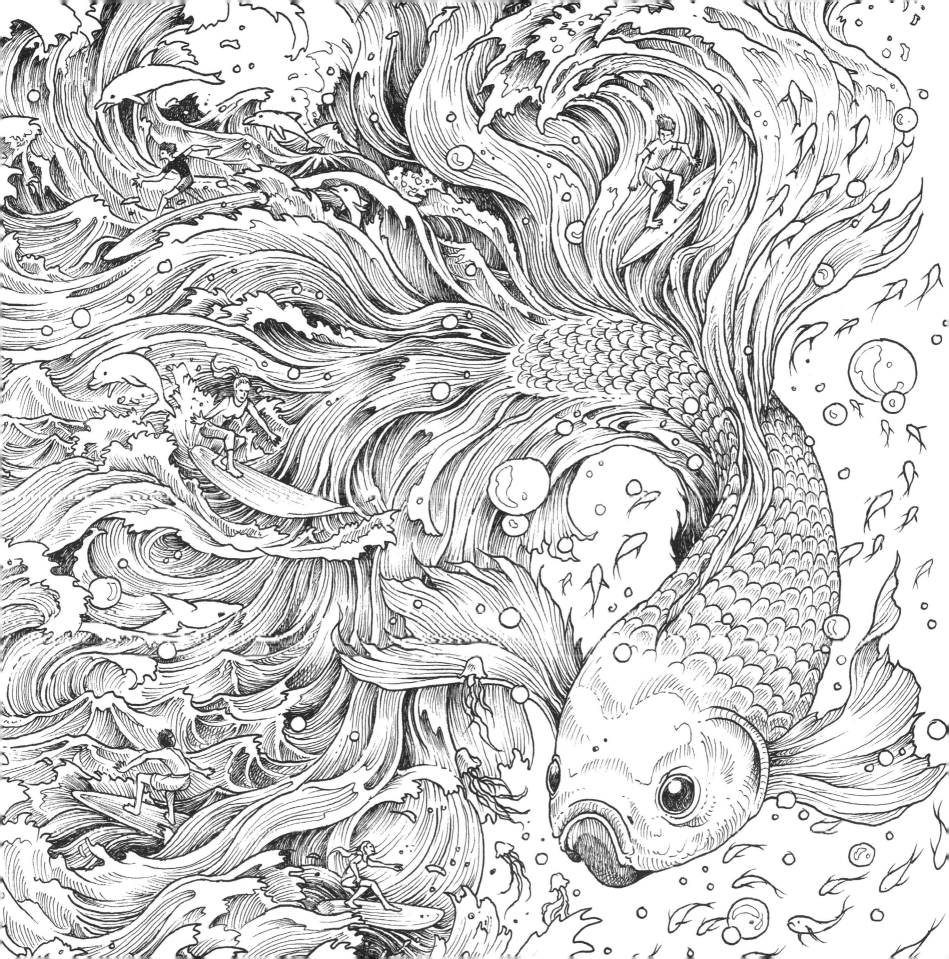

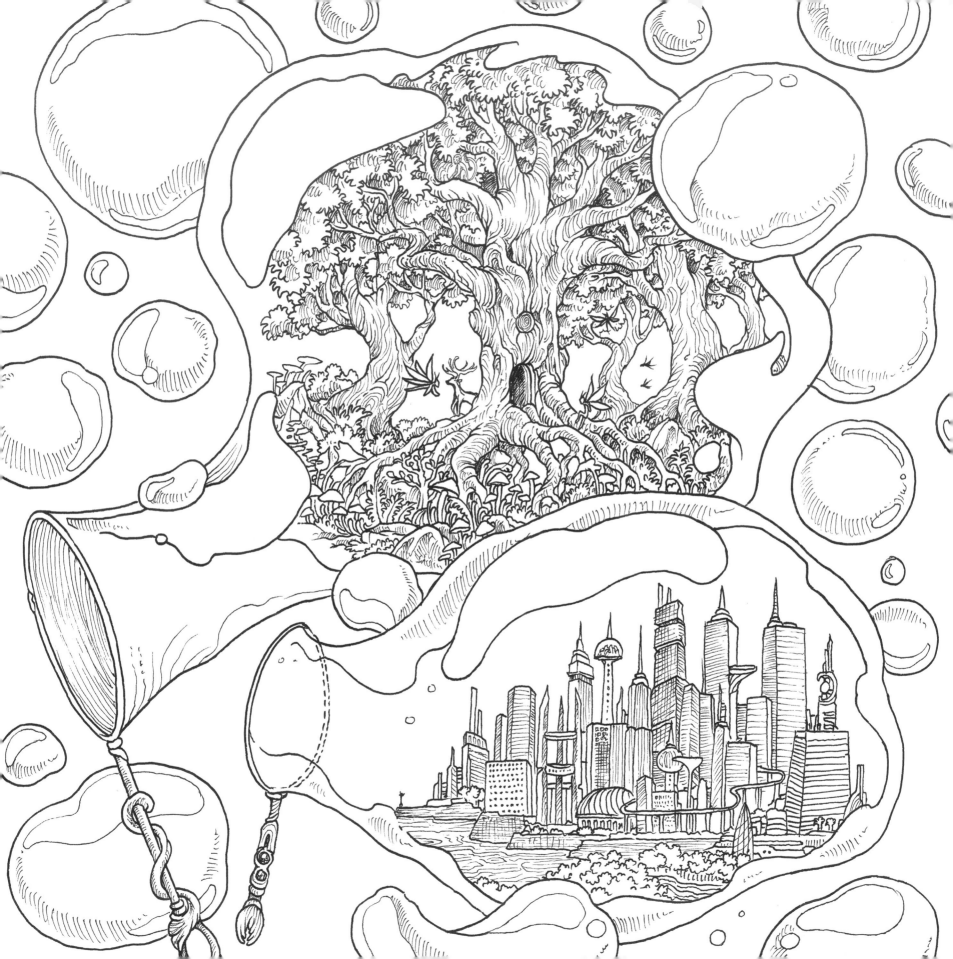

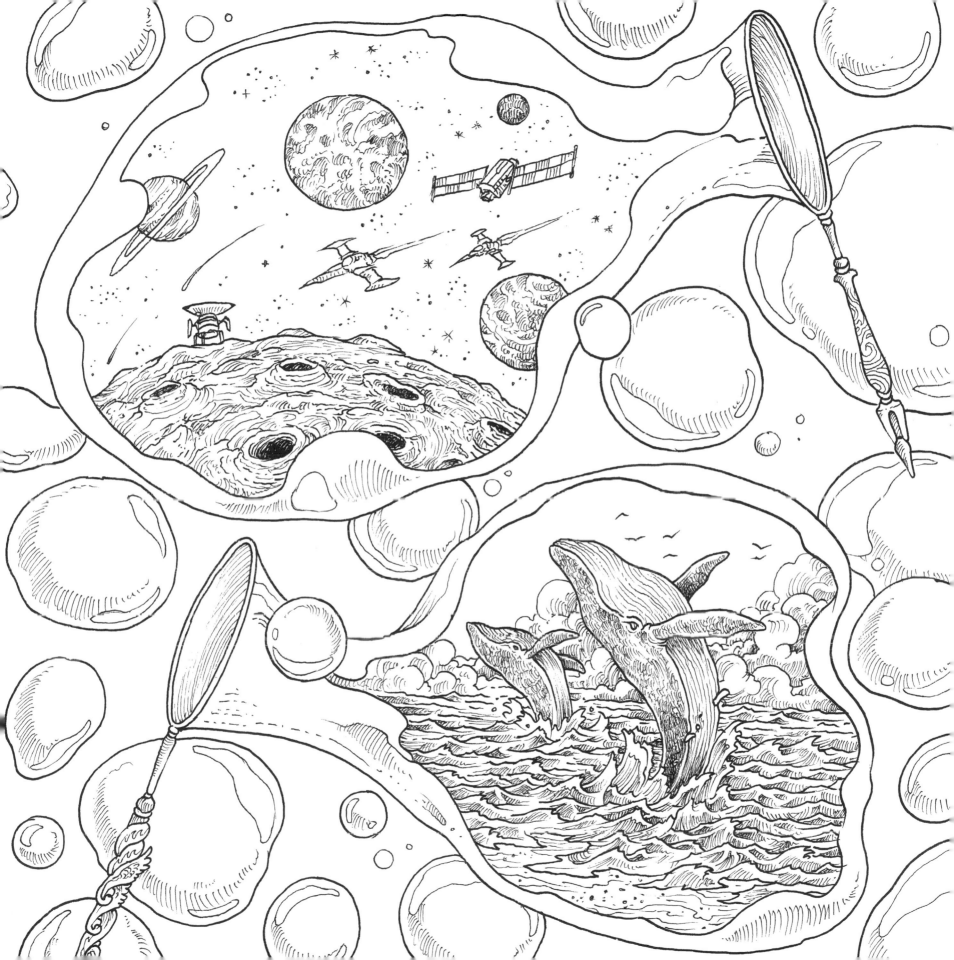

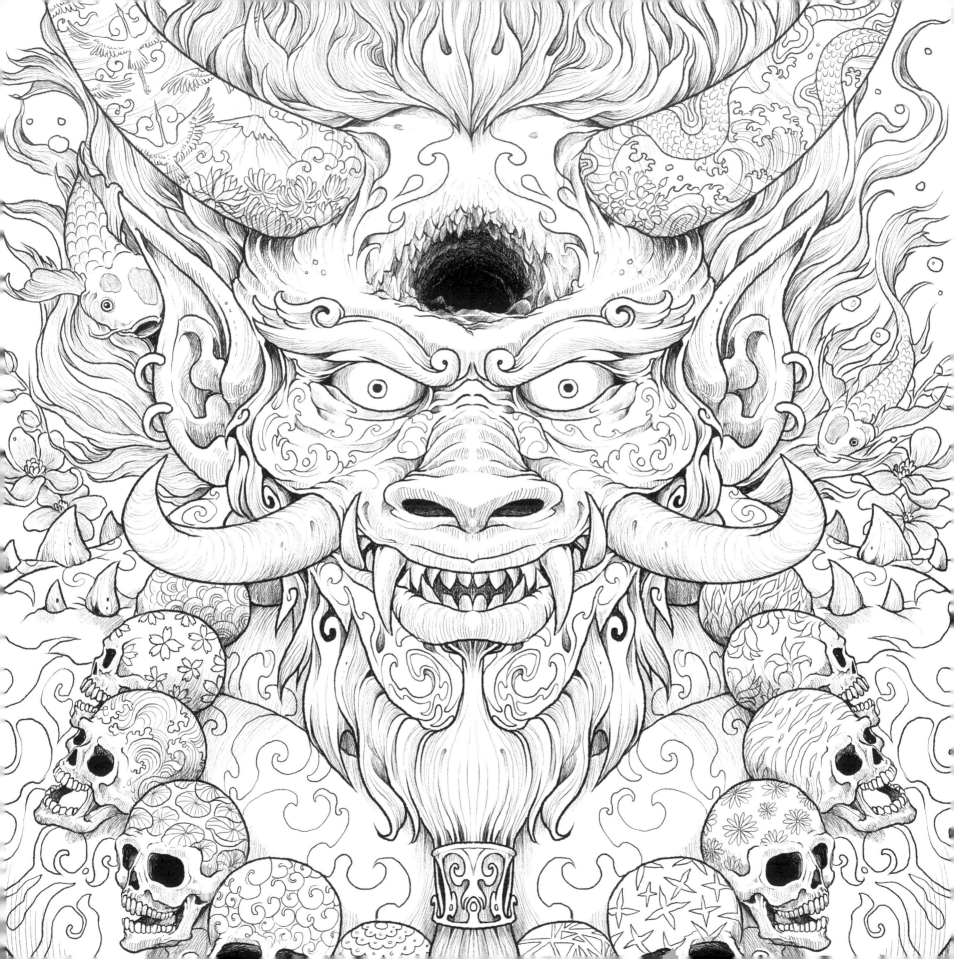

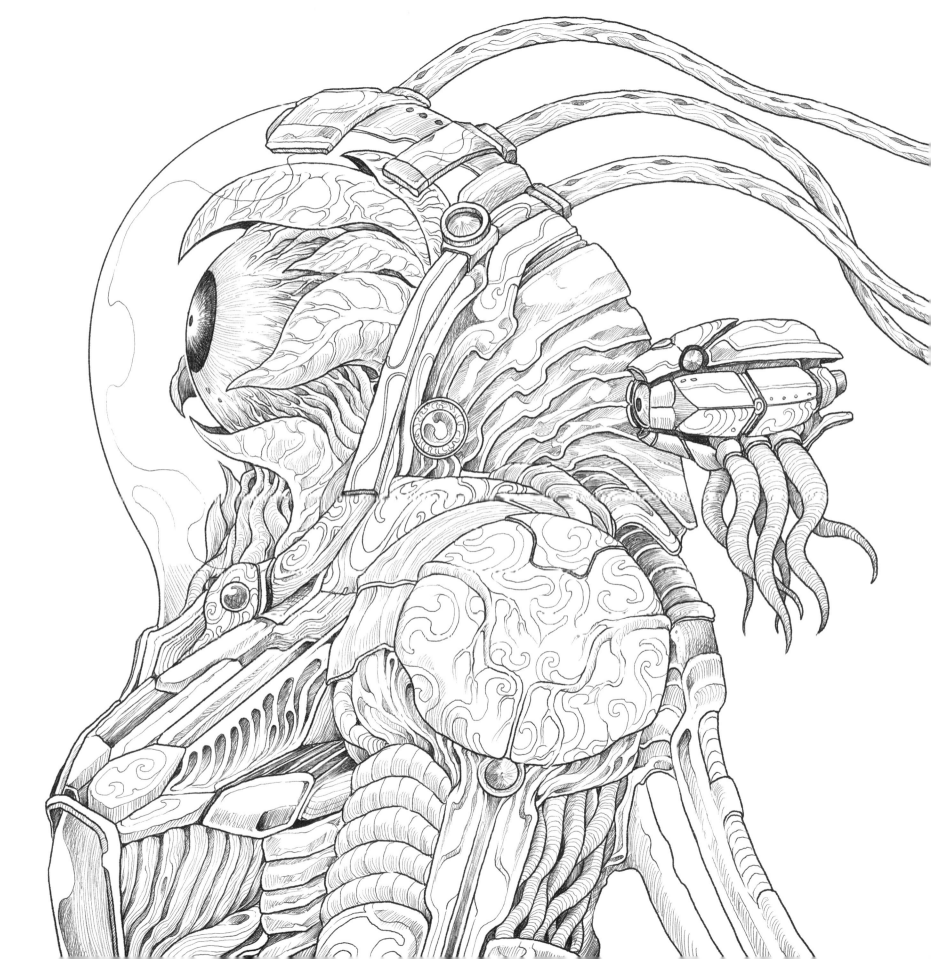

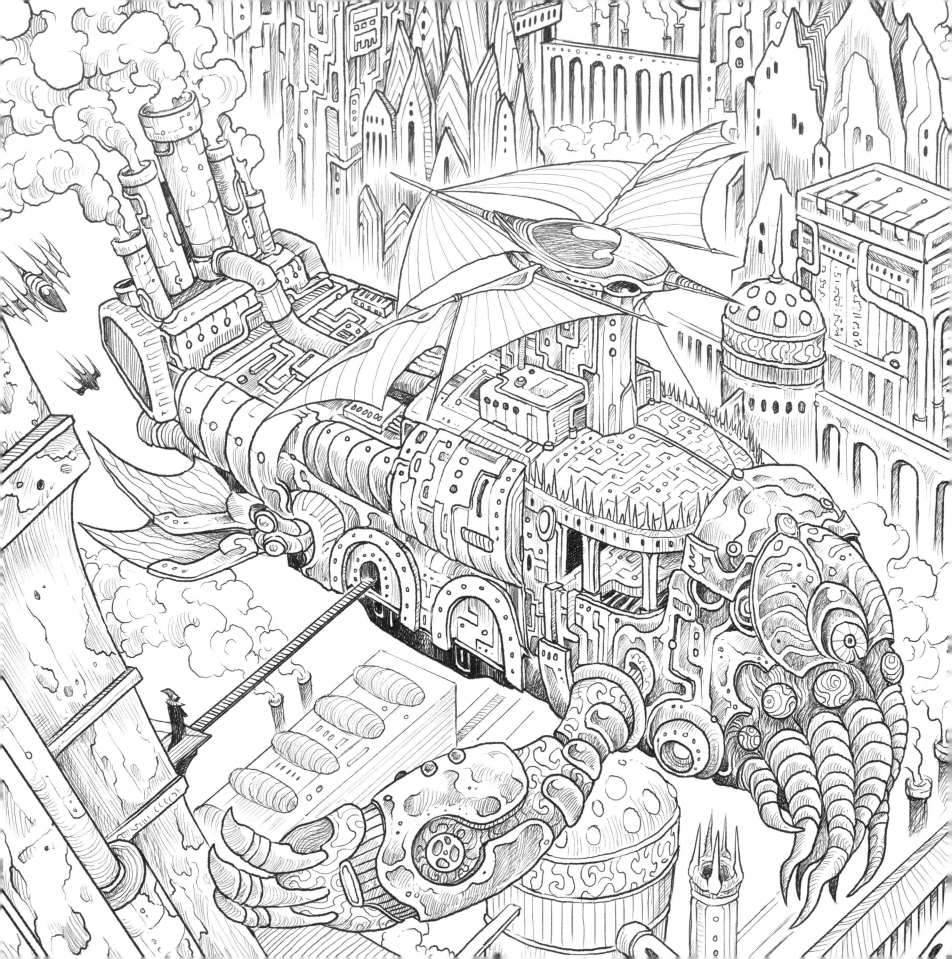

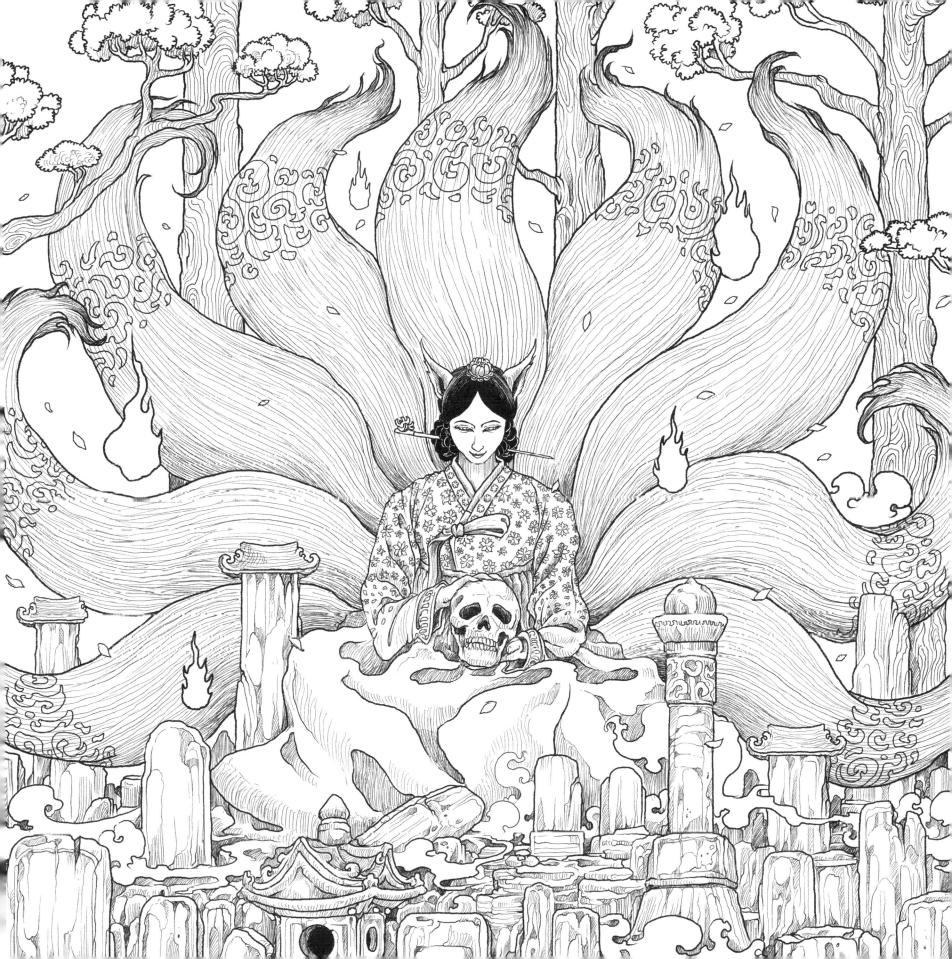

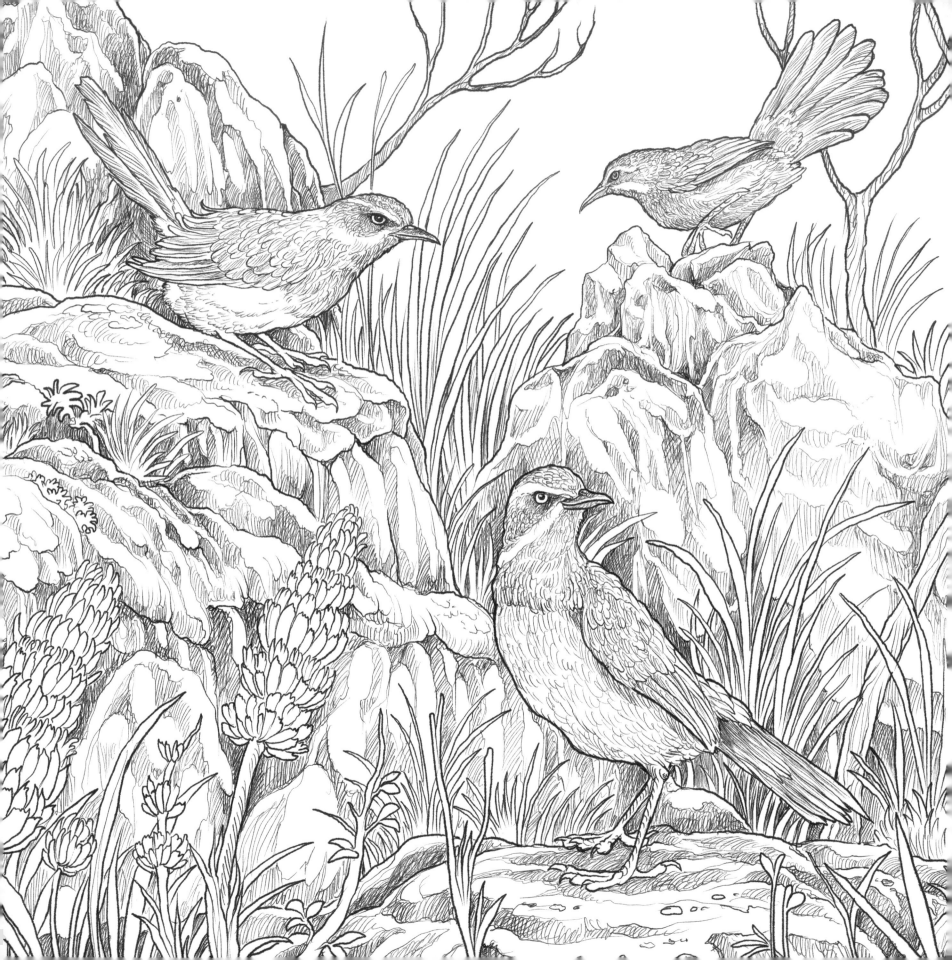

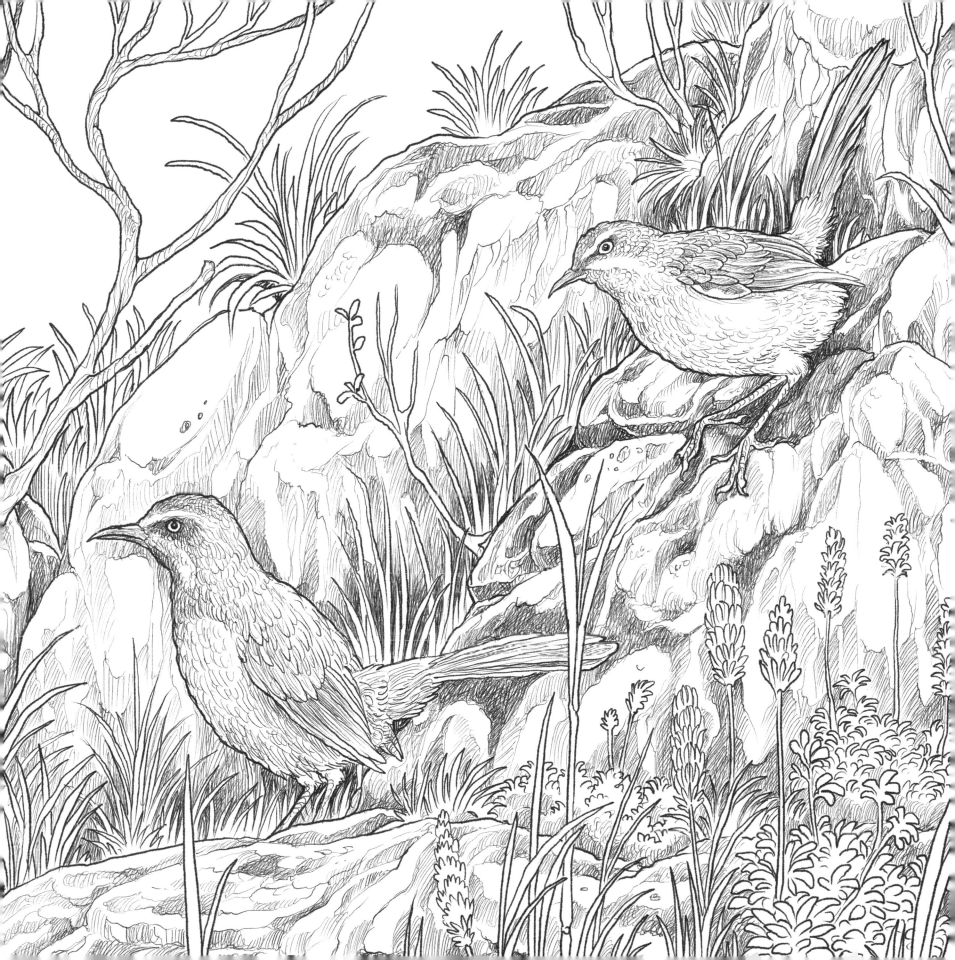

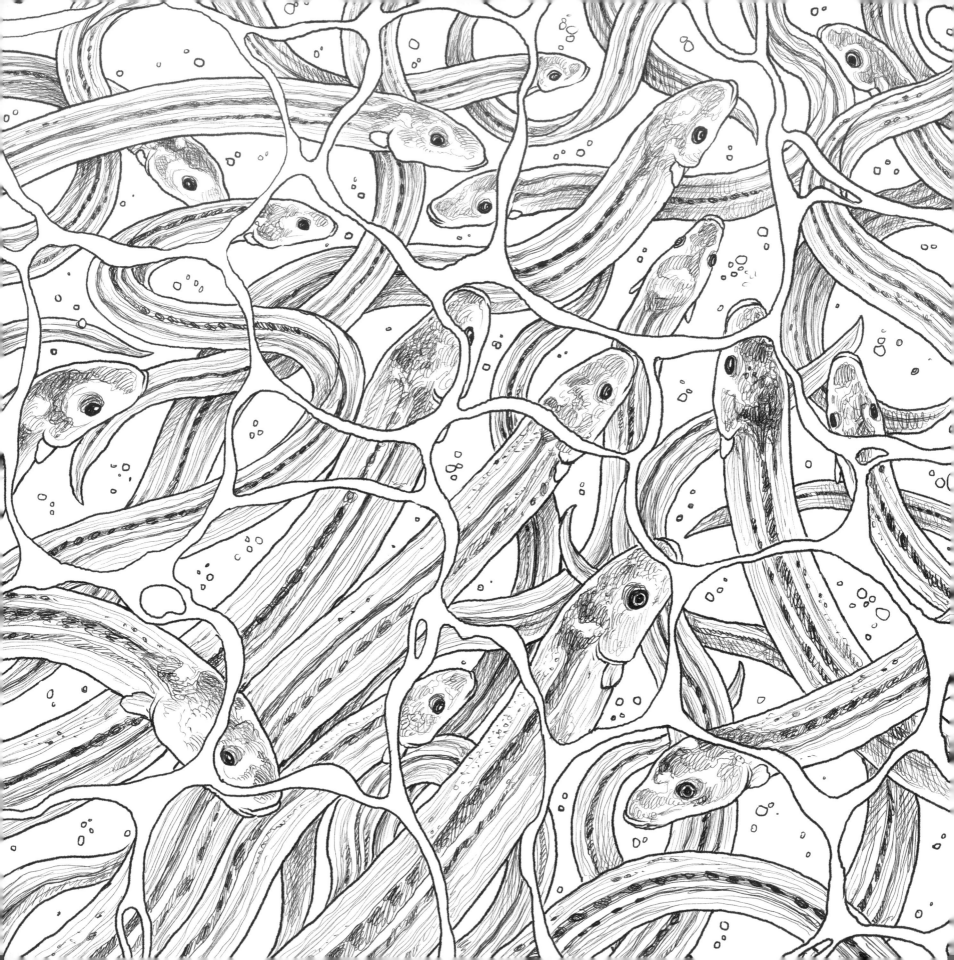

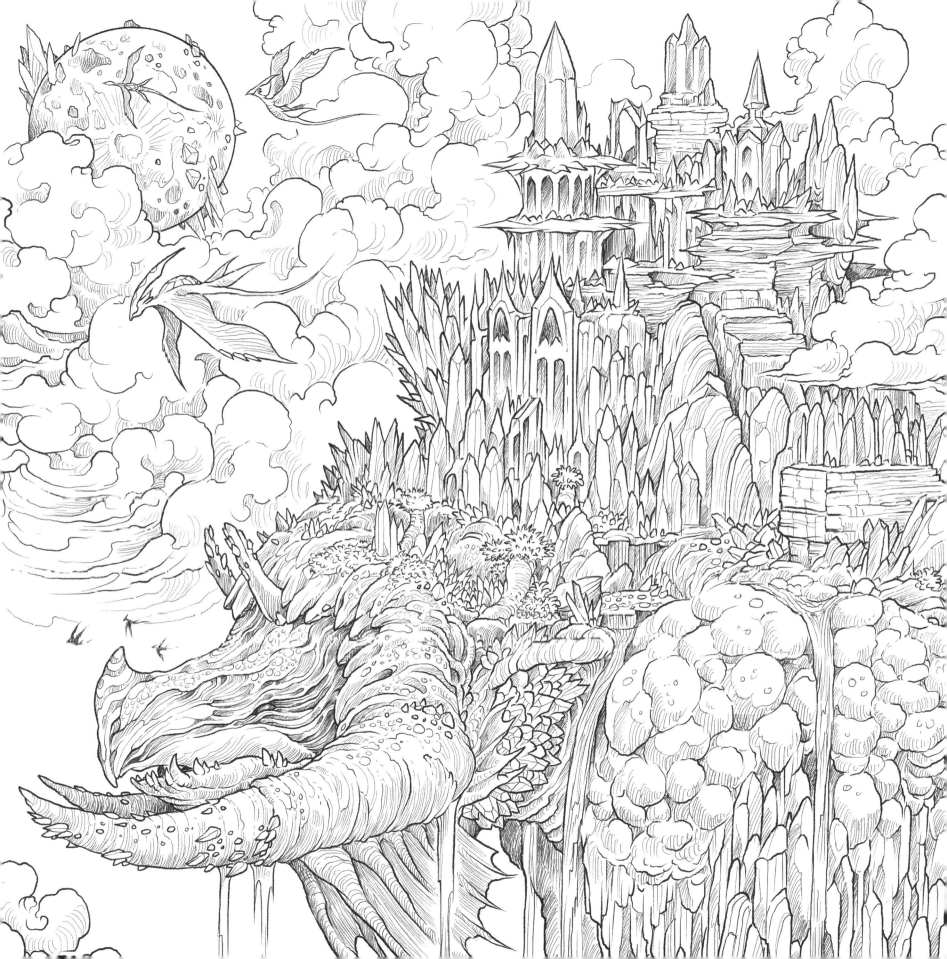

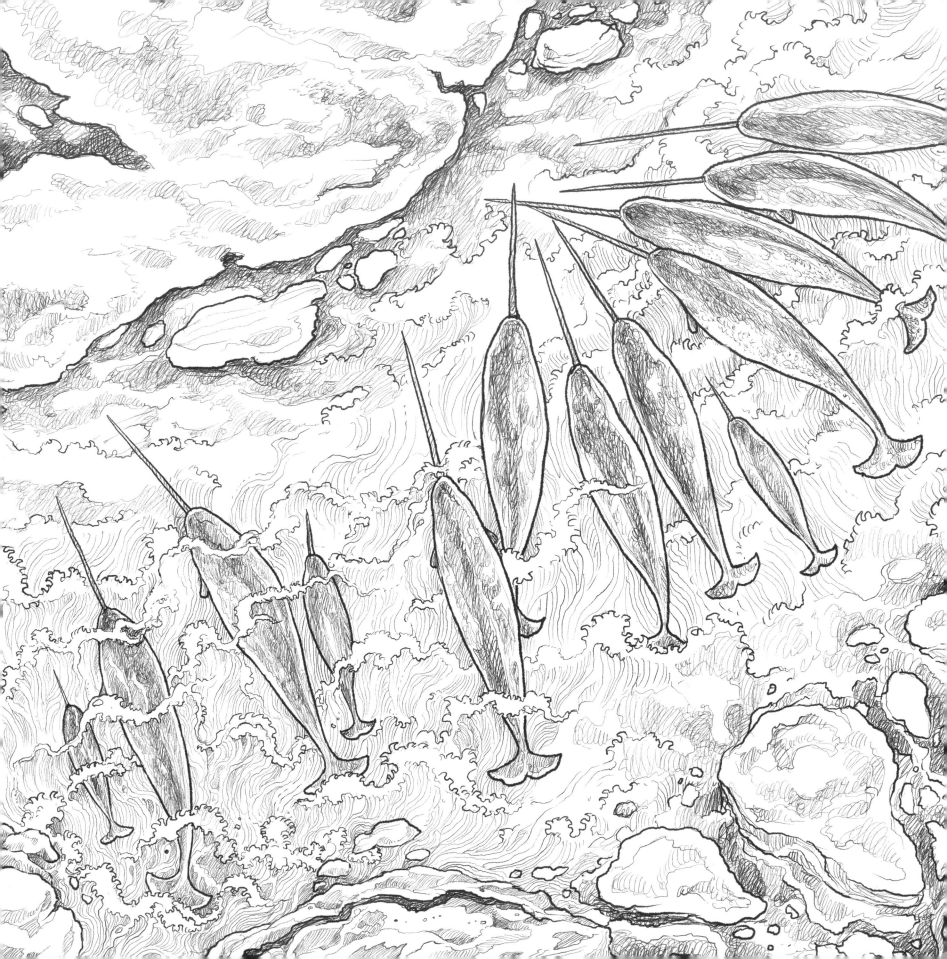

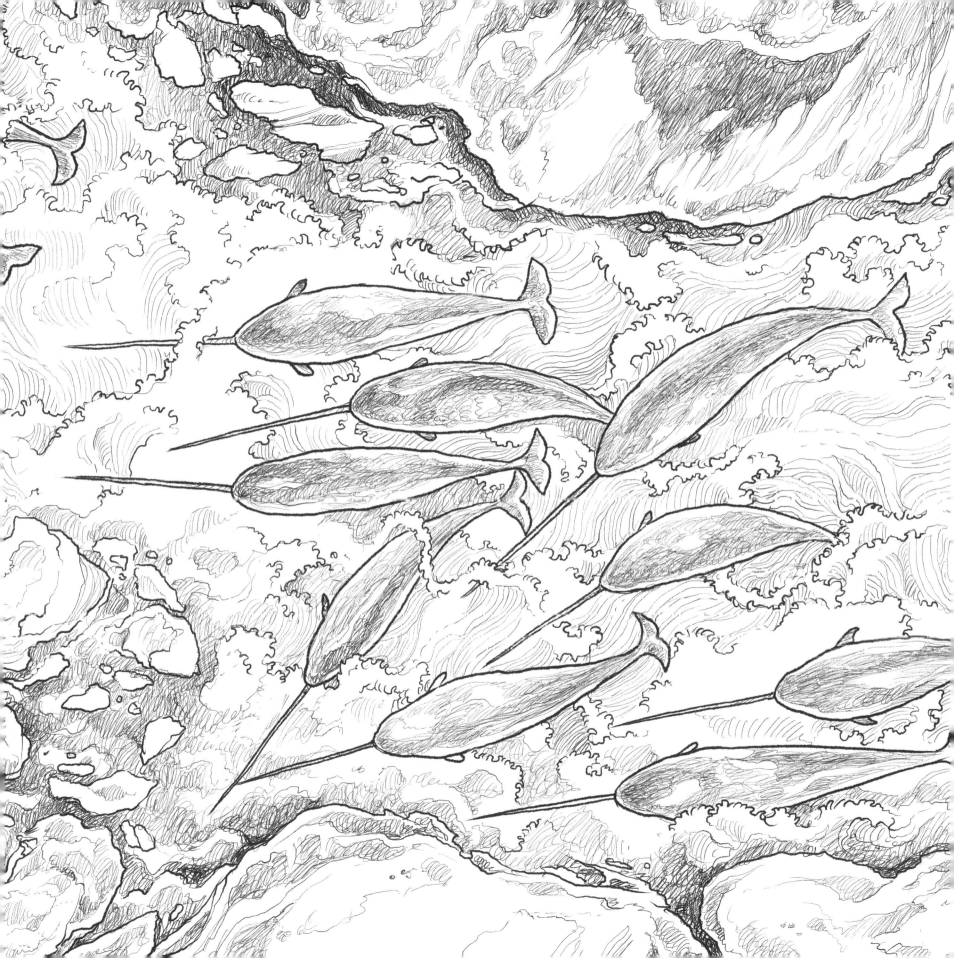

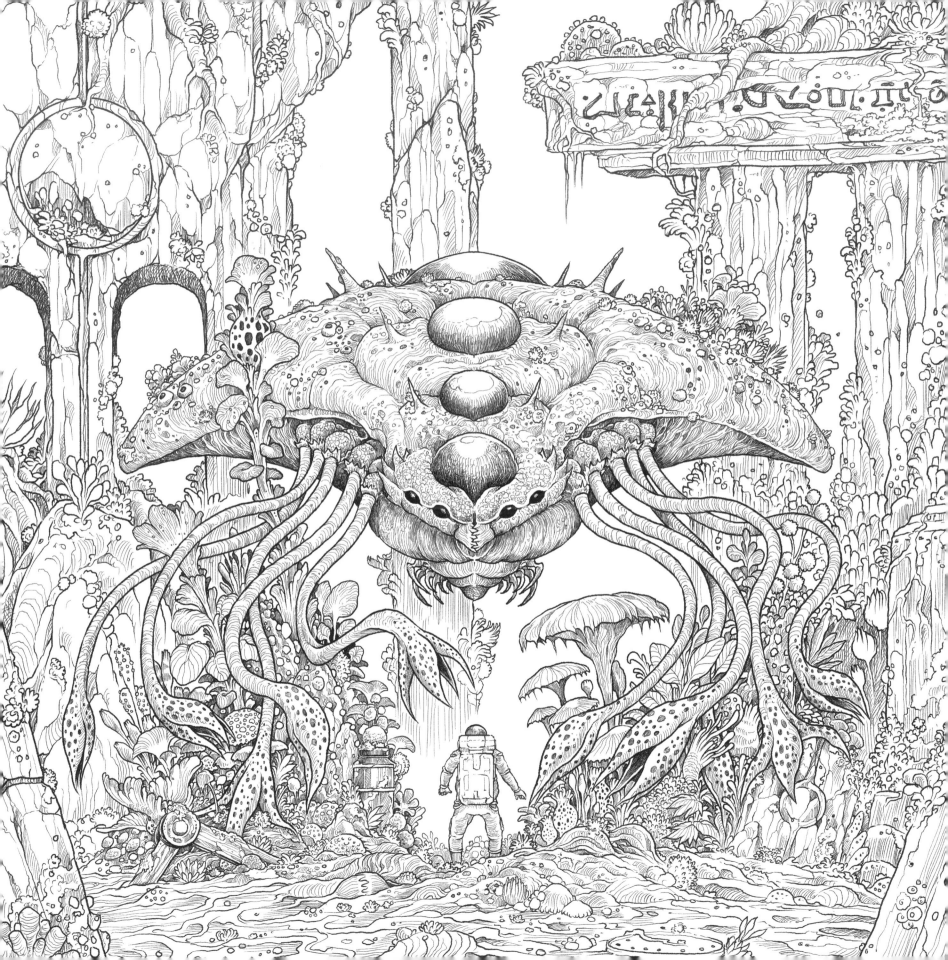

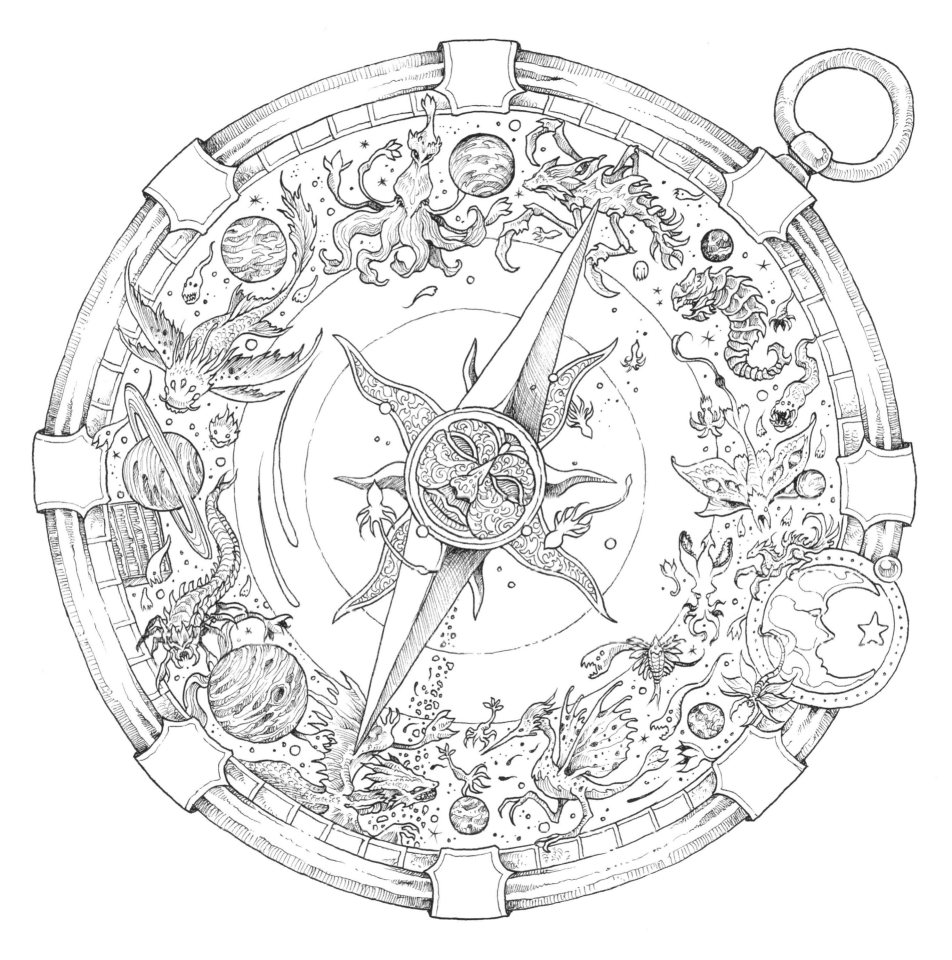

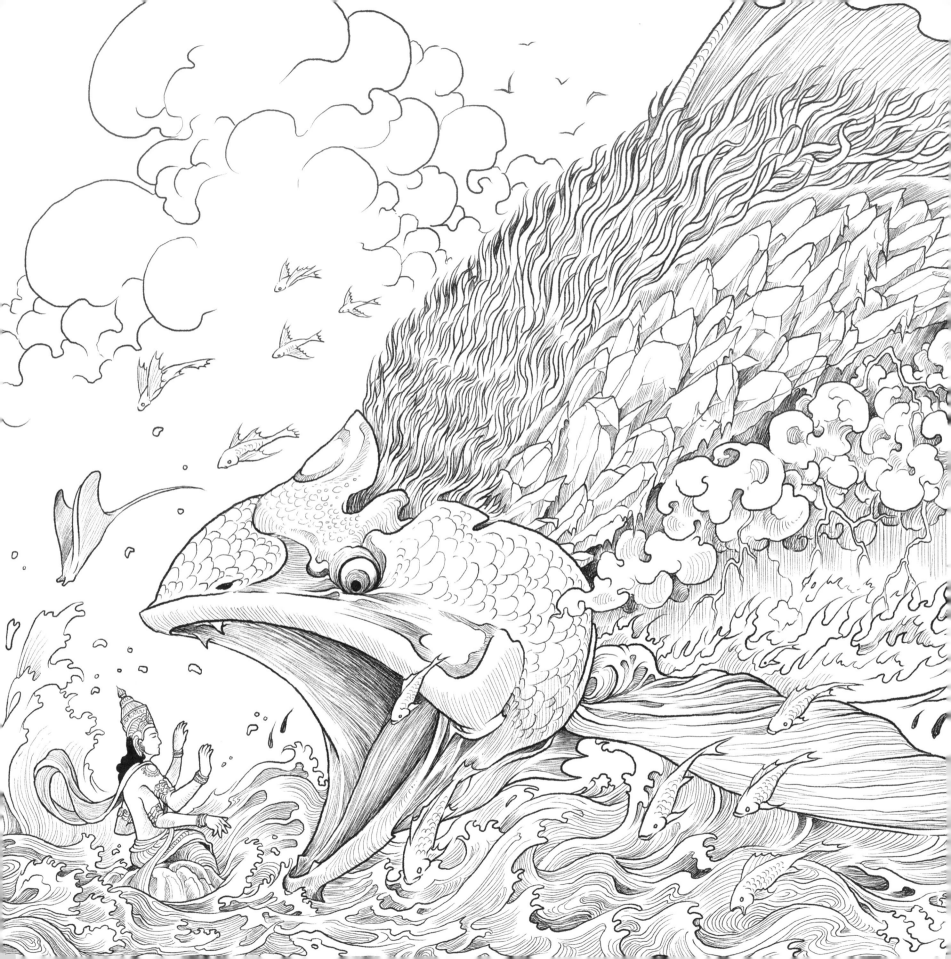

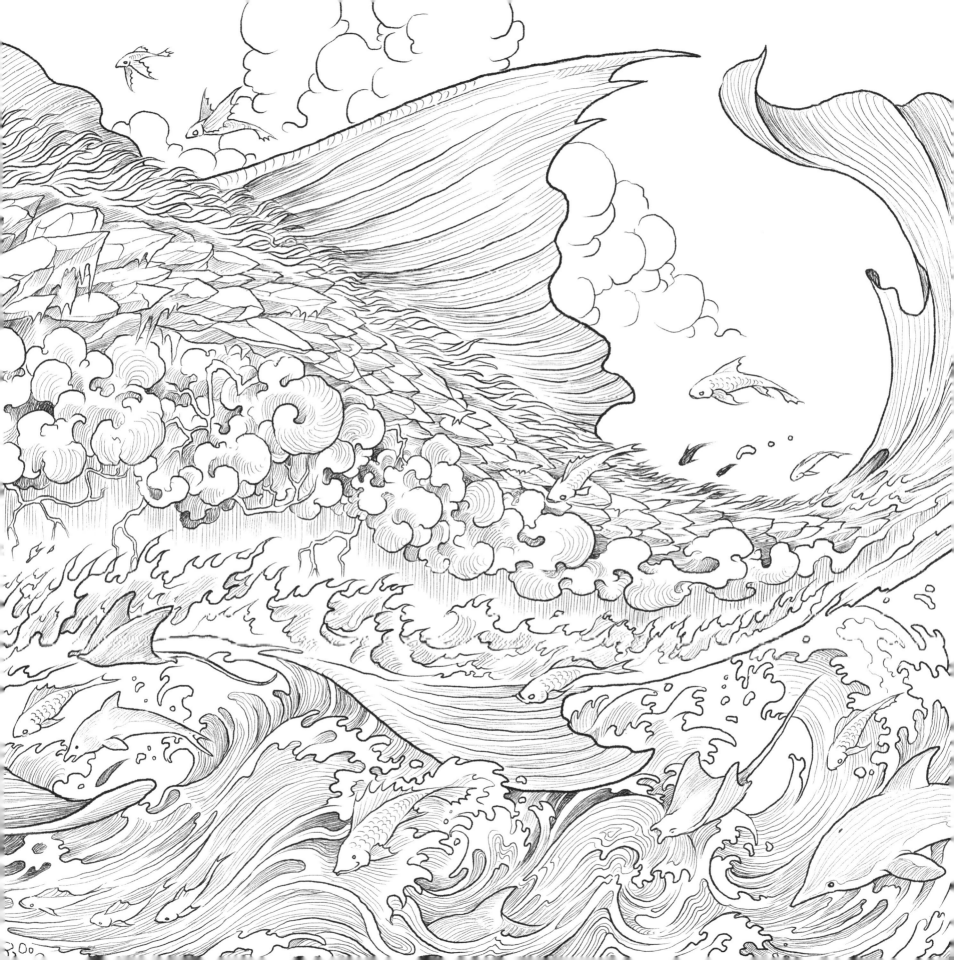

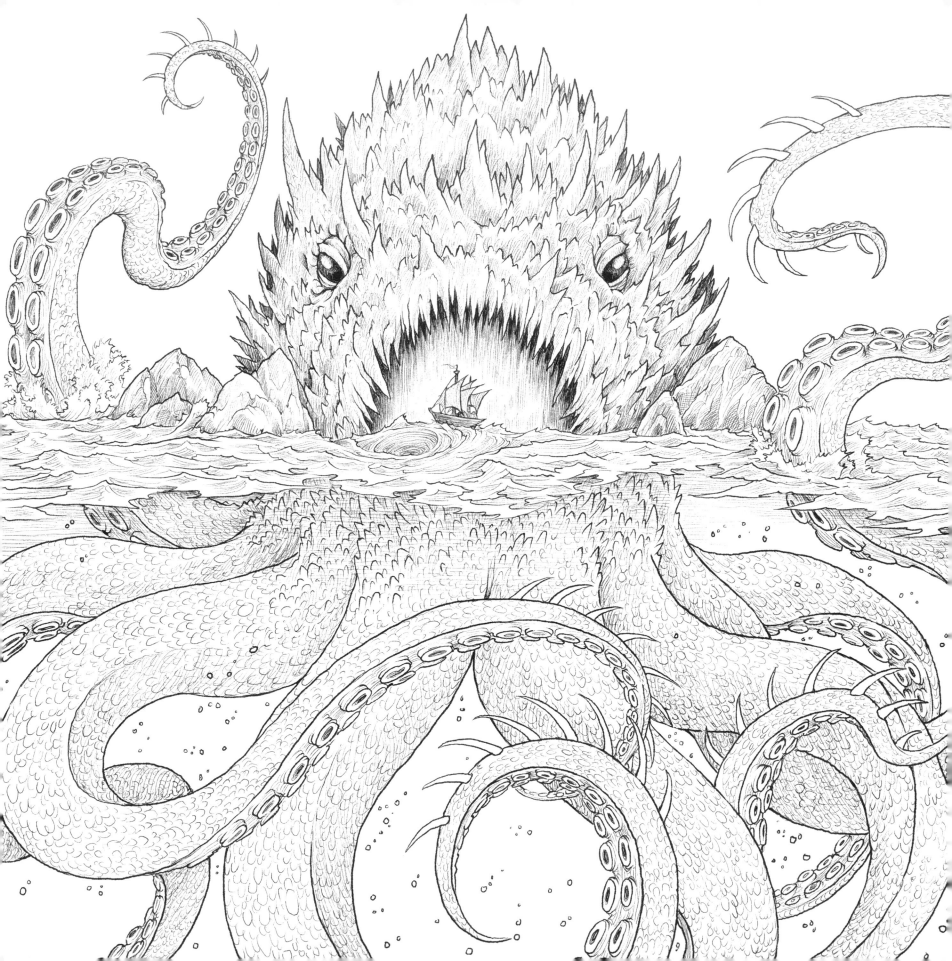

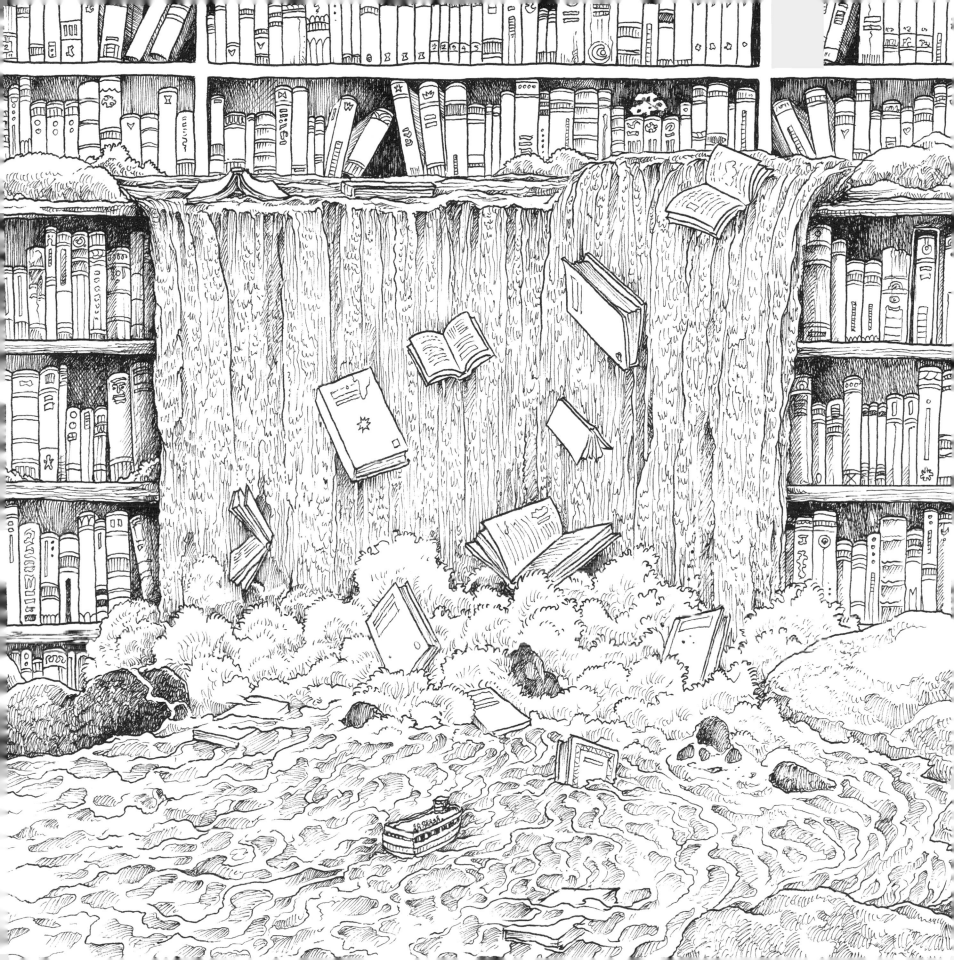

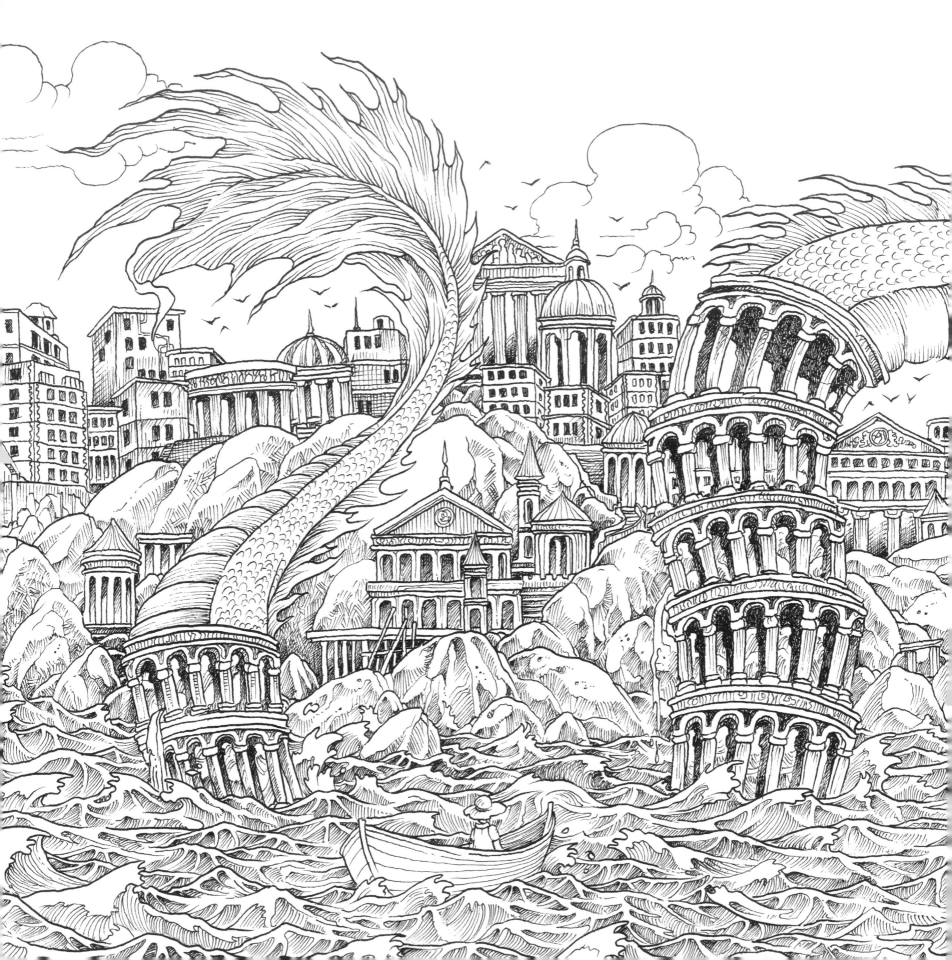

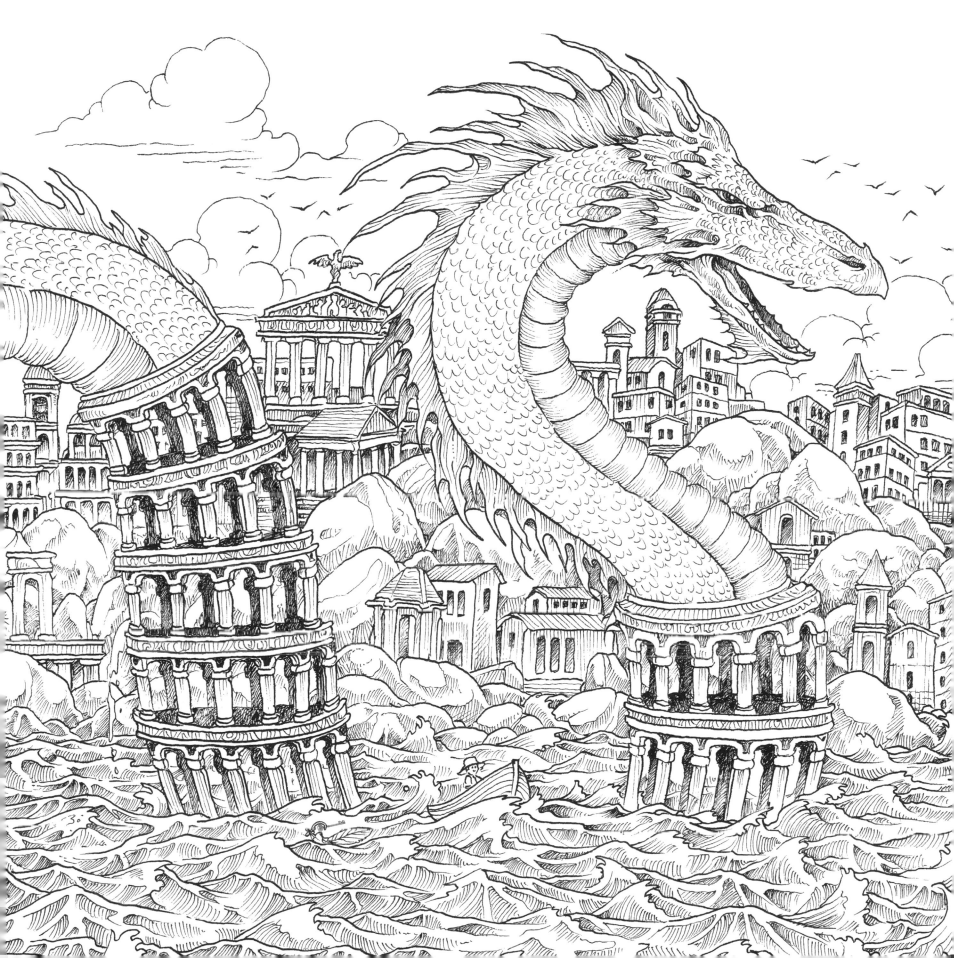

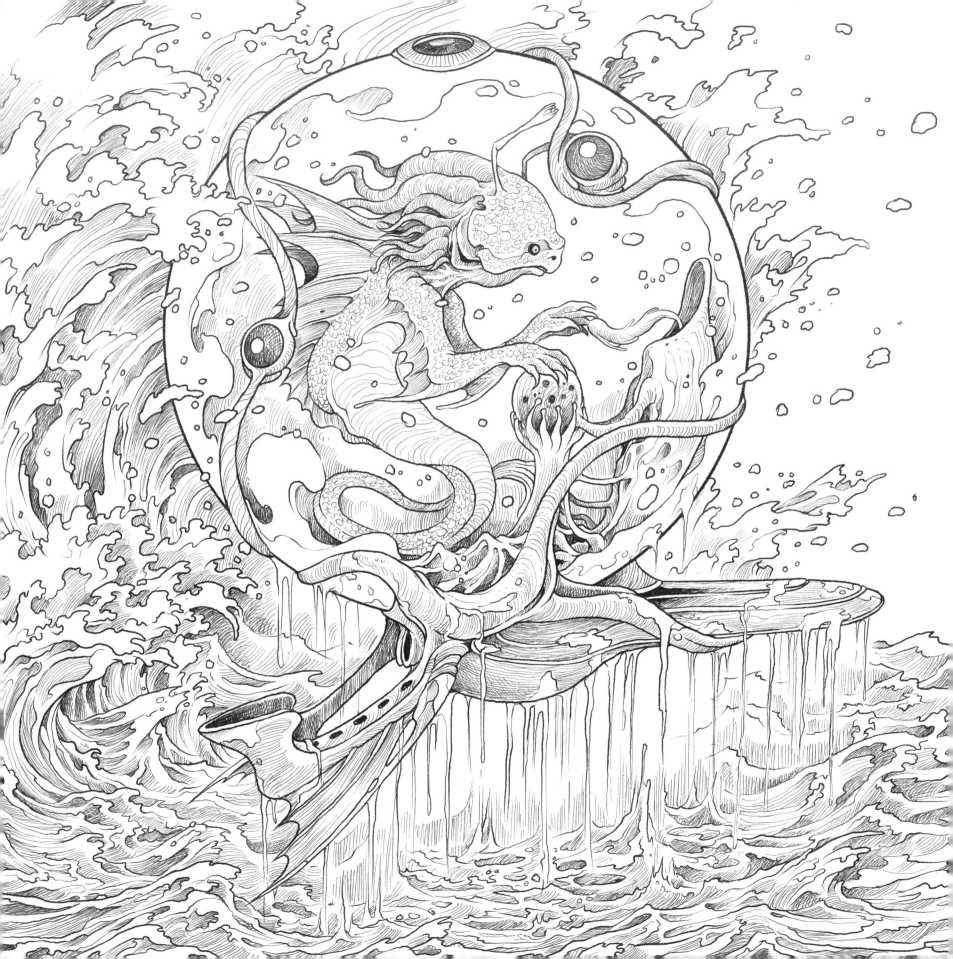

Illustrated by Kerby Rosanes

Edited by Josephine Southon

Designed by Derrian Bradder

Cover design by John Bigwood

Cover images colored by

Lauren Farnsworth (Fish)
and Laila Heldal (Stag)

with special thanks to Harry Thornton

PLUME
An imprint of Penguin Random House LLC
penguinrandomhouse.com

W mombooks.com/lom f Michael O'Mara Books OMaraBooks lomart.books

First published in Great Britain in 2023 by LOM ART, an imprint of
Michael O'Mara Books Limited, 9 Lion Yard, Tremadoc Road, London SW4 7NQ
The material in this book previously appeared in *Worlds Within Worlds: Color
New Realms*; *Fragile World: Color Nature's Wonders*; *Mythic World: Color
Timeless Legends*; and *Alien Worlds: Color Cosmic Kingdoms*.

Library of Congress Cataloging-in-Publication Data
has been applied for.

ISBN 9780593473955 (paperback)

Printed in the United States of America
1 3 5 7 9 10 8 6 4 2